*steering the craft*

## Selected Books by Ursula K. Le Guin

### FICTION

A Wizard of Earthsea

The Left Hand of Darkness

The Tombs of Atuan

The Lathe of Heaven

The Farthest Shore

The Dispossessed

The Word for World Is Forest

Very Far Away from Anywhere
Else

Malafrena

The Beginning Place

The Eye of the Heron

Always Coming Home

Searoad

Tehanu

The Telling

Four Ways to Forgiveness

Unlocking the Air

Tales from Earthsea

The Other Wind

Gifts

Voices

Powers

Lavinia

### POETRY

Wild Angels

Walking in Cornwall (chapbook)

Tillai and Tylissos (with Theodora
Kroeber; chapbook)

Hard Words

In the Red Zone (with Henk Pander;
chapbook)

Wild Oats and Fireweed

No Boats (chapbook)

Blue Moon over Thurman Street

Going Out with Peacocks

Sixty Odd

Incredible Good Fortune

Finding My Elegy

### TRANSLATION

Lao Tzu: Tao Te Ching

Selected Poems of Gabriela Mistral

# steering the craft

## A Twenty-First-Century Guide to Sailing the Sea of Story

## URSULA K. LE GUIN

HARPER PERENNIAL

HARPERCOLLINS*PUBLISHERS*

NEW YORK • LONDON • TORONTO • SYDNEY •
NEW DELHI • AUCKLAND

First Mariner Books edition 2015

www.harpercollins.com

*Library of Congress Cataloging-in-Publication Data is available.*
ISBN 978-0-544-61161-0

Book design by Endpaper Studios

Sailboat image by Celia Jaber, licensed from http://thenounproject.com/term/
sail-boat/17570/.

Printed in the United States of America
24 25 26 27 28  LBC  21 20 19 18 17

# contents

EXERCISES

*introduction*

## THIS BOOK

This is a handbook for storytellers — writers of narrative prose.

I want to say up front, it is not a book for beginners. It's meant for people who have already worked hard at their writing.

Fifteen or more years ago, I was getting students in my workshops who were serious, talented writers yet were afraid of semicolons and likely to confuse a point of view with a scenic vista. They needed to learn technique, to work on their craft, to get some navigational skills before they took the boat out across the Pacific. So in 1996 I developed a workshop called "Steering the Craft," focused on the glamorous aspects of writing, the really sexy stuff — punctuation, sentence length, grammar . . .

That five-day workshop drew fourteen intrepid writers, willing to face any semicolon and tame any verb tense. Their input and feedback was invaluable to me. Using my notes and their responses, I turned the workshop into a book, a self-guided set of discussion topics and exercises for a writer or a small group. Carrying on the title metaphor, I called them the Lone Navigator and the Mutinous Crew.

*Steering the Craft* was published in 1998. It met with an enthusiastic reception and sold steadily for about ten years. By then both writing and publishing were changing so fast that I began to think about updating the book. I ended up rewriting it from stem to stern.

It's still aimed at story-writers who seek thought, discussion, and practice in the fundamentals of narrative prose: the sound of it — punctuation, syntax, the sentence, the verb, the adjective; voice and point of view — direction and indirection; what's included and what's left out. Each chapter includes a *discussion* of the topic, *examples* of it from good writers, and *exercises* offering the reader guidance in avoiding pitfalls, practice in control, and a sense of the pleasure of writing, of playing the real, great word games.

All the material has been rethought, made clearer, more accurate, and more useful to writers of the twenty-first century. The exercises profited from a great deal of feedback from users of the book, reporting on which ones worked and which didn't, on the clarity or confusingness of directions, and so on. Peer group workshops are now so important to so many writers that I enlarged my discussion of them and suggestions for how to make them work and included more about online groups.

Our schools now often teach little of an essential and once

common knowledge, the vocabulary of grammar — the techspeak of language and writing. Words such as subject, predicate, object, or adjective and adverb, or past tense and past-perfect tense, are half understood by or wholly unfamiliar to many. Yet they're the names of the writer's tools. They're the words you need when you want to say what's wrong or right in a sentence. A writer who doesn't know them is like a carpenter who doesn't know a hammer from a screwdriver. ("Hey, Pat, if I use that whatsit there with the kinda pointy end, will it get this thing into this piece of wood?") In this revision, though I can't do a crash course in English grammar and usage, I urge my writer-readers to consider the value of the marvelous tools their language provides and to get truly familiar with them, so that they can play with them freely.

In the past twenty years, writing itself has begun to be differently understood in many ways, while publishing has been going through overwhelming and bewildering changes. I wanted my book to reflect the risks and chances of sailing the stormy waters of publishing — print and electronic — in this day and age, while never losing sight of the pole stars of the art of storytelling: how prose works and how a story moves.

There's no sea chart for a boat in a hurricane. But there are still some basic ways to make her seaworthy and keep her from capsizing, going to pieces, or hitting an iceberg.

## THE LONE NAVIGATOR AND THE MUTINOUS CREW

Collaborative workshops and writers' peer groups are good inventions. They put the writer into a community of people all working at the same art, the kind of group musicians and painters and dancers have always had. A good peer group of-

fers mutual encouragement, amicable competition, stimulating discussion, practice in criticism, and support in difficulty. If you want to and are able to join a group, do so. If you long for the stimulus of working with other writers but can't find or attend a local group, look into the many possibilities of forming or joining one on the Internet. You might form a Virtual Mutinous Crew using this book together via e-mail.

But if it doesn't work out, don't feel cheated or defeated. You can attend many writing workshops led by famous writers or be a member of many peer groups and yet get no closer to finding your own voice as a writer than you might do working alone in silence.

Ultimately you write alone. And ultimately you and you alone can judge your work. The judgment that a work is complete — *this is what I meant to do, and I stand by it* — can come only from the writer, and it can be made rightly only by a writer who's learned to read her own work. Group criticism is great training for self-criticism. But until quite recently no writer had that training, and yet they learned what they needed. They learned it by doing it.

## THE AIM

This is essentially a workbook. The exercises are consciousness-raisers: their aim is to clarify and intensify your awareness of certain elements of prose writing and certain techniques and modes of storytelling. Once we're keenly and clearly aware of these elements of our craft, we can use and practice them until — the point of all the practice — we don't have to think about

them consciously at all, because they have become skills.

A skill is something you know how to do. Skill in writing frees you to write what you want to write. It may also show you what you want to write. Craft enables art.

There's luck in art. And there's the gift. You can't earn that. But you can learn skill, you can earn it. You can learn to deserve your gift.

I'm not going to discuss writing as self-expression, as therapy, or as a spiritual adventure. It can be these things, but first of all — and in the end, too — it is an art, a craft, a making. And that is the joy of it.

To make something well is to give yourself to it, to seek wholeness, to follow spirit. To learn to make something well can take your whole life. It's worth it.

## STORYTELLING

All the exercises are concerned with the basic elements of narrative: how a story is told, what moves and what clogs it, starting right down on the level of the elements of language.

The topics are:

- the sound of language
- punctuation, syntax, the narrative sentence and paragraph
- rhythm and repetition
- adjectives and adverbs
- tense and person of the verb
- voice and point of view
- implicit narration: imparting information
- crowding, leaping, focus, and control.

As far as the exercises are concerned, it doesn't matter whether you write fiction or nonfiction — narrative is narrative. Most writing classes or courses in school and college focus on expository writing — giving information, explaining. They talk about "expressing ideas" but not about storytelling. Some of the techniques and values of expository writing are irrelevant and even problematic in narrative writing; training in the elaborately irresponsible language of bureaucracy or the artificially impersonal language of technology and science can tongue-tie a storyteller. Certain problems may be specific to memoir or fiction, and I'll mention those I'm aware of, but in general, all storytellers work pretty much the same way, with the same box of tools.

Since narrative is what this is all about, try to make each exercise not a static scene but the account of an act or action, something *happening.* It doesn't have to be bang-pow "action"; it might be a journey down a supermarket aisle or some thoughts going on inside a head. What it has to do is move — end up in a different place from where it started. That's what narrative does. It goes. It moves. Story is change.

## SUGGESTIONS FOR USING THE EXERCISES

Think about the directions for using each exercise a bit before you start writing. They may not be quite as simple as they look. Following them will make the exercise useful.

If you and this book are alone together, I suggest that you work through it methodically, doing the exercises in order. When you've worked on an exercise till you're more or less satisfied with it, put it away and forbid yourself to look at it again

for a while. One of the few things most writers agree on is that we can't trust our judgment on our own freshly written work. To see its faults and virtues we need to look at it after a real interval: a day or two at least.

Then reread your piece with a friendly, hopeful, critical eye, with revision in mind. If I offer specific suggestions for criticism regarding the exercise, use them now. Read the piece aloud to yourself, since speaking and hearing it will show up awkward bits and faults in the rhythm and can help you make dialogue natural and lively. In general, look for what's wordy, ugly, un-clear, unnecessary, preachy, careless — what breaks the pace, what doesn't work. Look for what does work, and admire it, and see if you can bring it out even better.

If you're part of a Mutinous Crew, I recommend that you fol-low the procedure outlined in the appendix, The Peer Group Workshop. All my suggestions for group work are based on this procedure. I've used it in all the workshops I've led and all the peer groups I've belonged to. It works.

Exercise pieces don't have to be highly finished; they don't have to be deathless literature. You can learn a lot by revising them. If they lead you on toward something bigger, that's grand, but to be successful as exercises, all they have to do is what the directions say to do. Most will be very short — a paragraph, a page or so. If you're working in a group and reading your pieces aloud, brevity is a necessity. And writing to a short, set length is an excellent discipline in itself. Of course your piece can grow longer later, if it leads you into something interesting.

My workshoppers told me it would be helpful if I suggested a subject or even a specific storyline or situation for each exer-cise. I provide these suggestions, but you don't have to use them.

They're for those who don't want to sit around inventing a universe in order to write an exercise.

If you're working in a group, you might choose to write some of the exercises during the meeting. After discussion of the exercise, each person sets to work on it. Silence: scribble scribble scribble. Half an hour is the absolute time limit. Then each one in turn reads their piece aloud, hot off the paper. The pressure often brings out excellent and surprising writing. In-class writing is tremendously useful for people who aren't used to producing under pressure and think they can't do it. (They can.) The Lone Navigator can get much the same effect by setting a half-hour time limit.

Each topical section introduces some matters to think or talk about, which the Lone Navigator can mull over at leisure or which might help get a discussion going in a group.

Most chapters include brief examples of various techniques taken from notably crafty writers. Do try reading them aloud, in the group or to yourself. (Don't be afraid of reading aloud alone! You'll only feel silly for a minute, and what you learn from reading aloud can last a lifetime.) The examples aren't meant to influence your approach to the exercise, only to show a variety of approaches to the technical problem in question.

If later on you want to try imitating one or another of them, do so. Students of composition and painting deliberately imitate great works of music and art as part of their training. The cult of originality led writing teachers to treat imitation as if it were despicable. By now, confused by the careless borrowing common on the Internet, a lot of writers don't know the difference between plagiarism, which *is* despicable, and imitation, which is useful. Intention matters. If you try to pass it off as your own,

that's plagiarism, but if you put your name on a paragraph "in the style of" a published author, it's just an exercise. Written seriously, not as parody or pastiche, it can be a demanding and revealing exercise. I talk about this a little more on page 93.

Most of the examples quoted in the book are taken from older works of fiction, because permission to quote from contemporary works is often expensive or unavailable, and because I love and am familiar with these older books. A lot of people have been scared away from the "classics" by inadequate teachers, or led to believe that writers learn only from their contemporaries. A writer who wants to write good stuff needs to read great stuff. If you don't read widely, or read only writers in fashion at the moment, you'll have a limited idea of what can be done with the English language.

The examples and the suggestions for further reading make good subjects for group discussion or for private study: What is this writer doing, how is she doing it, why is she doing it, do I like it? Finding other examples, bringing them to the group, discussing them, could be profitable to everybody in the crew. And the Lone Navigator may find guides, companions, dear friends among the writers who have also sailed these seas and found their way through the reefs and shoals.

*Note:* I use as little technical language as possible, but every craft needs its jargon, so I've appended a small glossary of technical or fancy terms. The first time I use such words I mark them with an asterisk.

*She slipped swift as a silvery fish*
*through the slapping gurgle of sea-waves.*

# 1. the sound of your writing

THE SOUND OF THE LANGUAGE IS WHERE it all begins. The test of a sentence is, Does it sound right? The basic elements of language are physical: the noise words make, the sounds and silences that make the rhythms marking their relationships. Both the meaning and the beauty of the writing depend on these sounds and rhythms. This is just as true of prose as it is of poetry, though the sound effects of prose are usually subtle and always irregular.

Most children enjoy the sound of language for its own sake. They wallow in repetitions and luscious word-sounds and the crunch and slither of onomatopoeia;* they fall in love with musical or impressive words and use them in all the wrong

places. Some writers keep this primal interest in and love for the sounds of language. Others "outgrow" their oral/aural sense of what they're reading or writing. That's a dead loss. An awareness of what your own writing sounds like is an essential skill for a writer. Fortunately it's quite easy to cultivate, to learn or reawaken.

A good writer, like a good reader, has a mind's ear. We mostly read prose in silence, but many readers have a keen inner ear that hears it. Dull, choppy, droning, jerky, feeble: these common criticisms of narrative are all faults in the sound of it. Lively, well-paced, flowing, strong, beautiful: these are all qualities of the sound of prose, and we rejoice in them as we read. Narrative writers need to train their mind's ear to listen to their own prose, to hear as they write.

The chief duty of a narrative sentence is to lead to the next sentence — to keep the story going. *Forward movement, pace, and rhythm* are words that are going to return often in this book. Pace and movement depend above all on rhythm, and the primary way you feel and control the rhythm of your prose is by hearing it — by listening to it.

Getting an act or an idea across isn't all a story does. A story is made out of language, and language can and does express delight in itself just as music does. Poetry isn't the only kind of writing that can sound gorgeous. Consider what's going on in these four examples. (Read them aloud! Read them aloud loudly!)

## Example 1

The *Just So Stories* are a masterpiece of exuberant vocabulary, musical rhythms, and dramatic phrasing. Rudyard Kipling has

let generations of kids know how nonsensically beautiful a story can *sound*. And there's nothing in either nonsense or beauty that restricts it to children.

### Rudyard Kipling: from "How the Rhinoceros Got His Skin" in *Just So Stories*

Once upon a time, on an uninhabited island on the shores of the Red Sea, there lived a Parsee from whose hat the rays of the sun were reflected in more-than-oriental splendour. And the Parsee lived by the Red Sea with nothing but his hat and his knife and a cooking-stove of the kind that you must particularly never touch. And one day he took flour and water and currants and plums and sugar and things, and made himself one cake which was two feet across and three feet thick. It was indeed a Superior Comestible (*that's* magic), and he put it on the stove because *he* was allowed to cook on that stove, and he baked it and he baked it till it was all done brown and smelt most sentimental. But just as he was going to eat it there came down to the beach from the Altogether Uninhabited Interior one Rhinoceros with a horn on his nose, two piggy eyes, and few manners. [. . .] And the Rhinoceros upset the oil-stove with his nose, and the cake rolled on the sand, and he spiked that cake on the horn of his nose, and he ate it, and he went away, waving his tail, to the desolate and Exclusively Uninhabited Interior which abuts on the islands of Mazanderan, Socotra, and the Promontories of the Larger Equinox.

This passage from Mark Twain's early story "The Celebrated Jumping Frog of Calaveras County" is totally aural/oral, its

beauty lying in its irresistible dialectical cadences. There are lots of ways to be gorgeous.

## Example 2

### Mark Twain: from "The Celebrated Jumping Frog of Calaveras County"

"Well, thish-yer Smiley had rat-tarriers, and chicken cocks, and tom cats and all them kind of things, till you couldn't rest, and you couldn't fetch nothing for him to bet on but he'd match you. He ketched a frog one day, and took him home, and said he cal'lated to educate him; and so he never done nothing for three months but set in his back yard and learn that frog to jump. And you bet you he did learn him, too. He'd give him a little punch behind, and the next minute you'd see that frog whirling in the air like a doughnut — see him turn one summerset, or maybe a couple, if he got a good start, and come down flat-footed and all right, like a cat. He got him up so in the matter of ketching flies, and kep' him in practice so constant, that he'd nail a fly every time as fur as he could see him. Smiley said all a frog wanted was education, and he could do 'most anything — and I believe him. Why, I've seen him set Dan'l Webster down here on this floor — Dan'l Webster was the name of the frog — and sing out, 'Flies, Dan'l, flies!' and quicker'n you could wink he'd spring straight up and snake a fly off'n the counter there, and flop down on the floor ag'in as solid as a gob of mud, and fall to scratching the side of his head with his hind foot as indifferent as if he hadn't no idea he'd been doin' any more'n any frog might do. You never see

a frog so modest and straightfor'ard as he was, for all he was so gifted. And when it come to fair and square jumping on a dead level, he could get over more ground at one straddle than any animal of his breed you ever see. Jumping on a dead level was his strong suit, you understand; and when it come to that, Smiley would ante up money on him as long as he had a red. Smiley was monstrous proud of his frog, and well he might be, for fellers that had traveled and been everywheres all said he laid over any frog that ever they see."

In the first example the more-than-oriental splendor of the language and in the second the irresistibly drawling aural cadences keep moving the story forward. In this one and the next, the vocabulary is simple and familiar; it's above all the rhythm that is powerful and effective. To read Hurston's sentences aloud is to be caught up in their music and beat, their hypnotic, fatal, forward drive.

## Example 3

### Zora Neale Hurston: from *Their Eyes Were Watching God*

So the beginning of this was a woman and she had come back from burying the dead. Not the dead of sick and ailing with friends at the pillow and the feet. She had come back from the sodden and the bloated; the sudden dead, their eyes flung wide open in judgment.

The people all saw her come because it was sundown. The sun was gone, but he had left his footprints in the sky. It was

the time for sitting on porches beside the road. It was the time to hear things and talk. These sitters had been tongueless, earless, eyeless conveniences all day long. Mules and other brutes had occupied their skins. But now, the sun and the bossman were gone, so the skins felt powerful and human. They became lords of sounds and lesser things. They passed nations through their mouths. They sat in judgment.

Seeing the woman as she was made them remember the envy they had stored up from other times. So they chewed up the back parts of their minds and swallowed with relish. They made burning statements with questions, and killing tools out of laughs. It was mass cruelty. A mood come alive. Words walking without masters; walking together like harmony in a song.

In the next passage, Tom, a middle-aged rancher, is coping with the early onslaught of the cancer he knows will kill him. Molly Gloss's prose is quiet and subtle; its power and beauty come from the perfect placement and timing of the words, the music of their sound, and the way the changing sentence rhythms embody and express the emotions of the characters.

*Example 4*

### Molly Gloss: from *The Hearts of Horses*

His flock of chickens had already gone in roost, and the yard was quiet — chickens will begin to announce themselves hours before sunrise as if they can't wait for the day to get started but they are equally interested in an early bedtime. Tom had

grown used to sleeping through their early-morning summons, all his family had, but in the last few weeks he'd been waking as soon as he heard the first hens peep, before even the roosters took up their reveille. The sounds they made in those first dark moments of the day had begun to seem to him as soft and devotional as an Angelus bell. And he had begun to dread the evenings — to wish, like the chickens, to climb into bed and close his eyes as soon as shadows lengthened and light began to seep out of the sky.

He let himself into the woodshed and sat down on a pile of stacked wood and rested his elbows on his knees and rocked himself back and forth. His body felt swollen with something inexpressible, and he thought if he could just weep he'd begin to feel better. He sat and rocked and eventually began to cry, which relieved nothing, but then he began to be racked with great coughing sobs that went on until whatever it was that had built up inside him had been slightly released. When his breathing eased, he went on sitting there rocking back and forth quite a while, looking at his boots, which were caked with manure and bits of hay. Then he wiped his eyes with his handkerchief and went into the house and sat down to dinner with his wife and son.

## FURTHER READING

Alice Walker's *The Color Purple* is notable for the splendid sound of its language. For quietly powerful rhythms, look at Sarah Orne Jewett's *The Country of the Pointed Firs* or Kent Haruf's fine Western novel *Plainsong*.

Fantasy is a form of narrative essentially dependent on its

language, and several classics of English prose, such as *Alice in Wonderland,* are fantasies. But keep your ear out when reading writers you mightn't associate with aural beauty; you may realize that much of the meaning has come to you through the sound and rhythm of the words.

~~~~~~~~~~~~~~~~~

## EXERCISE ONE: Being Gorgeous

**Part One:** Write a paragraph to a page of narrative that's meant to be read aloud. Use onomatopoeia, alliteration,* repetition, rhythmic effects, made-up words or names, dialect — any kind of sound effect you like — *but NOT rhyme or meter.**

~~~~~~~~~~~~~~~~~

I want you to write for pleasure — to play. Just listen to the sounds and rhythms of the sentences you write and play with them, like a kid with a kazoo. This isn't "free writing," but it's similar in that you're relaxing control: you're encouraging the words themselves — the sounds of them, the beats and echoes — to lead you on. For the moment, forget all the good advice that says good style is invisible, good art conceals art. Show off! Use the whole orchestra our wonderful language offers us!

Write it for children, if that's the way you can give yourself permission to do it. Write it for your ancestors. Use any narrating voice you like. If you're familiar with a dialect or accent, use it instead of vanilla English. Be very noisy, or be hushed. Try to reproduce the action in the jerky or flowing movement of the

THE SOUND OF YOUR WRITING

words. Make what happens happen in the sounds of the words, the rhythms of the sentences. Have fun, cut loose, play around, repeat, invent, feel free.

Remember — no rhyme, no regular meter. This is prose, not poetry!

I hesitate to suggest any "plot," but if you need some kind of hook to hang the language on, you might try telling the climax of a ghost story. Or invent an island and start walking across it — what happens?

**Part Two:** In a paragraph or so, describe an action, or a person feeling strong emotion — joy, fear, grief. Try to make the rhythm and movement of the sentences embody or represent the physical reality you're writing about.

*Performing and listening to* these pieces in a group can be a lot of fun. Not much critiquing* will be called for. The best response to a successful performance piece is applause.

If you're working alone, read your pieces aloud; perform them with vigor. Doing so will almost certainly lead you to improve the text here and there, to play some more with it, to make the sound of it still stronger and livelier.

*To think or talk about afterward:* Did concentrating on the sound of the writing release or enable anything unusual or surprising, a voice you haven't often used? Did you enjoy being gorgeous, or was it a strain? Can you say why?

The question of self-consciously "beautiful writing" is worthy of thought and discussion. How do you respond to the work of a novelist or essayist who visibly strives to write striking or poetical prose, using unusual or archaic words, combining words in a surprising way, going in for sound effects? Do you enjoy it? Does the conscious style do its work as prose? Does it intensify what it's saying or distract you from it?

Names are interesting sounds, and names of characters, the sound of them, the echo-allusions hidden in them, can be intensely expressive: Uriah Heep ... Jane Eyre ... Beloved ... Names of places, too: Faulkner's Yoknapatawpha County, Tolkien's haunting Lothlórien or his simple yet deeply evocative Middle-earth. It can be fun to think about names in fiction and what it is about the sound of them that makes them meaningful.

Being Gorgeous is a highly repeatable exercise, by the way, and can serve as a warm-up to writing. Try to set a mood by using verbal sound effects. Look at the view out the window or the mess on the desk, or remember something that happened yesterday or something weird that somebody said, and make a gorgeous sentence or two or three out of it. It might get you into the swing.

*Damn the semicolons cried*
*the captain full speed ahead*

# 2. punctuation and grammar

THE POET CAROLYN KIZER SAID TO ME once, "Poets are interested mostly in death and commas." Maybe storytellers are interested mostly in life and commas.

If you aren't interested in punctuation, or are afraid of it, you're missing out on some of the most beautiful, elegant tools a writer has to work with.

This topic is closely related to the last one, because punctuation tells the reader *how to hear* your writing. That's what it's for. Commas and periods bring out the grammatical structure of a sentence; they make it clear to the understanding, and the emotions, by showing what it sounds like — where the breaks come, where to pause.

If you read music, you know that rests are signs for silence. Punctuation marks serve very much the same purpose.

The period means stop for a moment the semicolon means pause and the comma means either pause very briefly or expect some change the dash is a pause that sets a phrase apart

Those words make sense if you work at it a bit. The work you're doing to make sense of them is punctuating them.

There are some firm rules of punctuation, but there's almost always a good deal of personal choice. The way I'd do it in this case is:

The period means stop — for a moment. The semicolon means pause; and the comma means either pause very briefly or expect some change. The dash is a pause that sets a phrase apart.

Some alternate choices are possible, but the *wrong* choices alter the meaning, or lose meaning altogether:

The period means stop. For a moment, the semicolon means pause and the comma means either. Pause very briefly or expect. Some change the dash. Is a pause that sets a phrase apart?

Some people who are ambitious about their writing and work hard on it in other ways breezily dismiss punctuation. Who cares where a comma goes? Once upon a time, sloppy writers could count on copy editors to put the commas where they belong and correct grammatical errors, but the copy editor is an endangered

species these days. As for the stuff in your computer that pretends to correct your punctuation or grammar,* disable it. These programs are on a pitifully low level of competence; they'll chop your sentences short and stupidify your writing. Competence is up to you. You're on your own out there with those man-eating semicolons.

I can't separate punctuation from grammar, because to a large extent learning how to write grammatically is learning how to punctuate, and vice versa.

Every writer I know has at least one manual of grammar to consult in case of doubt. Publishers often insist on *The Chicago Manual of Style* as the final authority, but its absolute and often arbitrary commandments, aimed for the most part at expository writing, don't always apply to narrative. The same is true of most college textbooks on style. I use an old manual, *The Elements of Style,* by Strunk and White. It's honest, clear, funny, and useful. Like all grammarians, Strunk and White are implacable in their opinions, and so an opposition movement has inevitably grown up. You can find newer and trendier guides. A brilliant and reliable handbook, recently revised, is Karen Elizabeth Gordon's *The Well-Tempered Sentence: A Punctuation Handbook for the Innocent, the Eager, and the Doomed.*

Ever since the Greeks, even in the Dark Ages, schools taught grammar as a foundation and essential element of education. In America, the early grades used to be called "grammar school." But toward the end of the last century, many of our schools all but stopped teaching grammar. Somehow we're supposed to be able to write without knowing anything about the equipment we're using. We're supposed to "express ourselves," to squeeze

out the orange juice of our souls, without being given anything to do it with, not even a knife to cut the orange.

Do we expect somebody to fix our kitchen sink without tools? Do we expect somebody to stand up and play the violin without having learned how to play the violin? Writing a sentence that expresses what you want to say isn't any easier than plumbing or fiddling. It takes craft.

## OPINION PIECE: CORRECTNESS AND MORALITY

Many of us believed the teacher who scolded us in second grade — "Billy, it's *wrong* to say 'It's me.' Say, 'It is I.'" Many of us cower before the grammar bullies who tell us that people who say "Hopefully" are *wrong*. Hopefully, some of us will continue to protest.

Morality and grammar are related. Human beings live by the word. Socrates said, "The misuse of language induces evil in the soul." I've had that sentence pinned up over my desk for a long time.

Lying is the deliberate misuse of language. But language misused through "mere" ignorance or carelessness breeds half-truths, misunderstandings, and lies.

In that sense grammar and morality are related. In that sense a writer's moral duty is to use language thoughtfully and well.

But Socrates wasn't talking about correctness. Correct usage is not "right," or incorrectness "wrong," morally. Correctness isn't a moral issue but a social and political one, often a definition of social class. Correct usage is defined by a group of those who speak and write English a certain way, and used as a test or shibboleth to form an in-group of those who speak and write

English that way and an out-group of those who don't. And guess which group has the power?

I detest the self-righteousness of the correctness bullies, and I distrust their motives. But I have to walk a razor's edge in this book, because the fact is that usage, particularly in writing, is a social matter, a general social agreement about how we make ourselves understood. Incoherent syntax,* mistaken words, misplaced punctuation, all cripple meaning. Ignorance of the rules makes hash of the sentences. In written prose, incorrect usage, unless part of a conscious, consistent dialect or personal voice, is disastrous. An egregious mistake in usage can invalidate a whole story.

How can a reader trust a writer ignorant of the medium she works in? Who can dance to a fiddler who plays off key?

Our standards for writing are different than for speaking. They have to be, because when we read, we don't have the speaker's voice and expression and intonation to make half-finished sentences and misused words clear. We have only the words. They must be clear. And making things clear in writing for strangers involves a lot more work than in talking face-to-face.

Hence some of the pitfalls of writing on the Internet, highly visible in e-mail, blogs, and responses to blogs. The mechanical ease and immediacy of electronic communication are deceptive. People write hurriedly, don't reread what they wrote, misread and are misread, get into quarrels, hurl insults, and use flame-throwers because they expect their writing to be understood as if they were talking.

It's childish to assume people will understand unexpressed meanings. It's dangerous to confuse self-expression with communication.

*The reader has only the words.* Emoticons are dreary little excuses for a failure to communicate feelings and intentions in words. Using the Net is easy, but getting your meaning across there is just as hard as it is in print. Perhaps harder, because it appears that a lot of people more read hastily and carelessly on the screen than on the page.

Writing can be completely conversational and informal, but to communicate thought or emotion of any complexity at all, it has to follow the general agreements, the shared rules of grammar and usage. Or, if it breaks them, it breaks them intentionally. To break a rule you have to know the rule. A blunder is not a revolution.

If you don't know the real rules, you may fall for fake ones. I keep running into fake Rules of Good Writing based on hokey grammar vocabulary. Here's an example:

Fake Rule: Sentences beginning "There is . . ." are in the passive tense. Good writers never use the passive tense.

Good writers use the "There is" construction all the time. "There was a black widow spider on the back of his wrist." "There is still hope." It's called an existential construction used to introduce a noun. It's quite basic and very useful.

There's no such thing as "the passive tense." Passive and active aren't tenses, they're modes of the verb. Each mode is useful and correct where appropriate. Good writers use both.

Bureaucrats, politicians, administrators, etc., use the "There is . . ." construction to avoid taking responsibility for a statement. Here is Governor Rick Scott speaking of a hurricane threat to the Republican Convention in Florida: "There's not an antici-

pation that there will be a cancellation." You can see how the innocent and useful construction got a bad name.

And here's an example of deliberate violation of a Fake Rule:

Fake Rule: The generic pronoun in English is *he.*
Violation: "Each one in turn reads their piece aloud."

This is wrong, say the grammar bullies, because *each one, each person* is a singular noun and *their* is a plural pronoun. But Shakespeare used *their* with words such as *everybody, anybody, a person,* and so we all do when we're talking. ("It's enough to drive anyone out of their senses," said George Bernard Shaw.)

The grammarians started telling us it was incorrect along in the sixteenth or seventeenth century. That was when they also declared that the pronoun *he* includes both sexes, as in "If a person needs an abortion, he should be required to tell his parents."

My use of *their* is socially motivated and, if you like, politically correct: a deliberate response to the socially and politically significant banning of our genderless pronoun by language legislators enforcing the notion that the male sex is the only one that counts. I consistently break a rule I consider to be not only fake but pernicious. I know what I'm doing and why.

And that's the important thing for a writer: to know what you're doing with your language and why. This involves knowing usage and punctuation well enough to use them skillfully, not as rules that impede you but as tools that serve you.

Look at the "Jumping Frog" passage (on p. 4): the usage is deliberately "incorrect," but the punctuation is impeccable, and plays a tremendous part in keeping the dialectical usages and cadences clear to the reader's ear. Careless punctuation makes a

written sentence unclear and ugly. Wise punctuation keeps the flow running clear. And that's what matters.

The exercise is a pure consciousness-raiser. I'm trying to get you thinking about the value of punctuation by forbidding you to use it.

~~~~~~~~~~~~~~~~~~~~

## EXERCISE TWO: Am I Saramago

Write a paragraph to a page (150–350 words) of narrative *with no punctuation* (and no paragraphs or other breaking devices).

*Suggested subject:* A group of people engaged in a hurried or hectic or confused activity, such as a revolution, or the scene of an accident, or the first few minutes of a one-day sale.

~~~~~~~~~~~~~~~~~~~~

*For a group:* Just for once, let the group read the piece in silence first. The likelihood is that, read aloud by the author, it won't be too hard to follow. How comprehensible was it without the author's voice?

*To think or talk about in critiquing the exercise:* How well does the unbroken flow of words fit the subject? To what extent does the unpunctuated flow actually shape the narrative?

*To think about after writing it:* What writing it felt like; how it differed from writing with the usual signs and guides

and breaks; whether it led you to write differently from the way you usually write or gave you a different approach to something you've tried to write. Was the process valuable? Is the result readable?

If punctuation is something you've generally avoided thinking about, here's a challenge: sit down all by yourself and go through a few paragraphs of a book you like and admire and just study the punctuation. What's the author doing, why did she break that sentence that way, why did she want a pause there, how much of the rhythm of the prose is actually established by the punctuation, how's it done?

*A week later:* It may be interesting, now, to go through your workshop piece and punctuate it. The unpunctuated passage had to find a way to make itself clear without punctuation. To punctuate it may involve rewriting it. Which version do you think works better?

A four-part sentence I read as a child in a book of puzzles demonstrates quite spectacularly the Power of Punctuation in general and the Purpose of the Semicolon in particular. Unpunctuated, it is as follows:

> All that is is all that is not is not that that is is not that that is not that is all.

All you need to make it make sense is three semicolons. You could use all periods, but it would be jerky.

*The wind died. The sail fell slack. The boat*
*slowed, halted. We were becalmed.*

# 3. sentence length and complex syntax

THE SENTENCE IS A MYSTERIOUS ENTITY, and I'm not going to try to say what it is, only talk about what it does.

In a narrative, the chief duty of a sentence is to lead to the next sentence.

Beyond this basic, invisible job, the narrative sentence can of course do an infinite number of audible, palpable, beautiful, surprising, powerful things. In order to do them, it needs one quality above all: coherence. A sentence has to hang together.

Incoherent, straggling, patched-together sentences can't lead seamlessly to the next sentence, because they can't even hold themselves together. Good grammar is pretty much like good

engineering: the machine works because the parts do. Careless grammar is bad design plus sand in the gears and the wrong size gaskets.

Here are some of the commonest problems in sentence design, and the first is the commonest.

## MISPLACEMENT

*She fell down as she stood up and broke her nose.*

*The conversation was all about the accident which was very boring.*

*He was sure when the test came he could pass it.* (Does this mean that when the test appeared on his desk he saw that it was easy, or does it mean he was sure that whenever the test came, he was ready for it?)

*She, which was quite unnecessary, sent a snitty reply to his e-mail.*

*She sent a snitty reply to his e-mail, which was quite unnecessary.*

*She sent a snitty reply to his email unnecessarily.*

Think of it like this: there's one best way for the parts of a sentence to fit together, and your job as a writer is to find it. You may not notice anything's out of place till you're rereading to revise. All that's needed may be a slight rearrangement of order, or you may have to rethink and rewrite the sentence entirely. (How would you fix the three failed attempts above, the sentence about the snitty reply?)

## DANGLERS

*Leaving the house, a giant oak towered over them.*

*After eating a good dinner, the sofa looks plump and alluring.*

Almost all writers leave some danglers, and some do little harm; but walking trees and carnivorous sofas can really wreck the scenery.

## CONJUNCTIVITIS

*They were happy and they felt like dancing and then they felt like they had been reading too much Hemingway and it was night.*

*They wanted to be happy but it was too dark to dance but nobody had any good music anyway.*

Stringing short sentences together with conjunctions is a legitimate stylistic mannerism, but used naively, it sets up a kind of infantile droning that makes the story hard to follow.

And you want the reader to keep following you. You are the Pied Piper, your sentences are the tune you play, and your readers are the children of Hamelin (or, if you prefer, the rats.)

Paradoxically, if your piping is very fancy, if your sentences are highly unusual or ornamental, they may distract the reader from following you. This is where the overquoted and rather nasty advice about "killing your darlings" applies: to the sentence that's so grand it stops the story. A sentence isn't working as a narrative sentence if its order is so unexpected, or its adjectives and adverbs so striking, or its similes* or metaphors* so dazzling, that it stops the reader, even to say "Ooh!"

Poetry can get away with that. In poetry a line, a few words, can make the reader catch breath, cry, stop reading in order to feel the beauty, hold the moment. And many people admire the elaborate, ornate prose of writers such as Nabokov, which

I find difficult to get through because it's always stopping to be admired.

I think it's fair to say that though every sentence should move with grace, the proper beauty and power of prose is in the work as a whole.

The first exercise was Being Gorgeous, because I wanted to start with the neglected fact that good writing *always* gives pleasure to the ear. But in most good narrative, especially long narrative, it's less the immediate dazzle of the words than the sounds, rhythms, setting, characters, action, interactions, dialogue, and feelings all working together that make us hold our breath, and cry . . . and turn the page to find out what happens next. And so, until the scene ends, each sentence should lead to the next sentence.

Every sentence has a rhythm of its own, which is also part of the rhythm of the whole piece. Rhythm is what keeps the song going, the horse galloping, the story moving.

And the rhythm of prose depends very much — very prosaically — on the *length* of the sentences.

Teachers trying to get kids to write understandably, textbooks of style with their notion of "transparent" style, journalists with their weird rules and superstitions, and bang-pow thriller writers — they've all helped filled a lot of heads with the notion that the only good sentence is a short sentence.

A convicted criminal might agree. I don't.

And the pity of it is that people not only can't write complex sentences, they can't read them. "Oh, I can't read Dickens, it's all long sentences." We are losing our literature to a dumbing-down process.

Very short sentences, isolated or in a series, are highly effec-

tive in the right place. Prose consisting entirely of short, syntactically simple sentences is monotonous, choppy, irritating. If short-sentence prose goes on very long, whatever its content, the *thump-thump* beat gives it a false simplicity that soon just sounds stupid. See Spot. See Jane. See Spot bite Jane.

It's a myth that short-sentence prose is "more like the way we speak." A writer can build a sentence in a more deliberate way than a speaker can, because a writer can ponder and revise. But people often use more long, well-articulated* sentences when they speak than when they write. We follow a complex thought aloud by using a wealth of clauses* and qualifiers. Dictation is notoriously wordy. When Henry James began dictating his novels to a secretary, his tendency to qualify and parenthesize and embed clause within clause got out of hand, clogging the narrative flow and making his prose totter on the edge of self-parody. Listening with a careful ear to one's prose isn't the same thing as falling in love with the sound of one's voice.

Narrative prose consisting largely of long, complex sentences, full of embedded clauses* and all the rest of the syntactical armature,* takes some care. Long sentences have to be carefully and knowledgeably managed, solidly constructed; their connections must be clear, so that they flow, carrying the reader along easily. The marvelously supple connections of complex syntax are like the muscles and sinews of a long-distance runner's body, ready to set up a good pace and keep going.

There is no optimum sentence length. The optimum is *variety*. The length of a sentence in good prose is established by contrast and interplay with the sentences around it — and by what it says and does.

*Kate fires the gun.* A short sentence.

*Kate perceives that her husband's not paying any real attention to what she's saying to him, but also observes that she doesn't much care if he's paying attention or not, and that this lack of feeling may be a sinister symptom of something she doesn't want to think about just now.* This kind of subject may well require a complex sentence that can work itself out at some length.

In revision you can consciously check for variety, and if you've been jerking along in short, choppy sentences or slogging through a bog of long ones, play with them to achieve a varied rhythm and pace.

## Example 5

Jane Austen's prose is still near enough to the balanced style of the eighteenth century that it may sound stately or over-composed to a modern ear; but read it aloud, which you'll find surprisingly easy, and you'll hear how vivid and versatile it is and feel its easy strength. (The dialogue in many film versions of Austen novels is taken almost unchanged from the books.) The syntax is complex but clear. Many of the connections that lengthen the sentences are semicolons, so that most of these sentences would have been equally "correct" if Austen had used periods instead of semicolons. Why didn't she?

The second paragraph is all one sentence. If you read it aloud, you'll hear how the length of the sentence gives weight to the last clause of it. Yet it isn't heavy, because it's broken into rhythmic repetitions: "How wretched, and how unpardonable, how hopeless and how wicked it was . . ."

## Jane Austen: from *Mansfield Park*

As a general reflection on Fanny, Sir Thomas thought nothing could be more unjust, though he had been so lately expressing the same sentiments himself, and he tried to turn the conversation; tried repeatedly before he could succeed; for Mrs. Norris had not discernment enough to perceive, either now, or at any other time, to what degree he thought well of his niece, or how very far he was from wishing to have his own children's merits set off by the depreciation of hers. She was talking *at* Fanny, and resenting this private walk half through the dinner.

It was over, however, at last; and the evening set in with more composure to Fanny, and more cheerfulness of spirits than she could have hoped for after so stormy a morning; but she trusted, in the first place, that she had done right, that her judgment had not misled her; for the purity of her intentions she could answer; and she was willing to hope, secondly, that her uncle's displeasure was abating, and would abate farther as he considered the matter with more impartiality, and felt, as a good man must feel, how wretched, and how unpardonable, how hopeless and how wicked it was, to marry without affection.

When the meeting with which she was threatened for the morrow was past, she could not but flatter herself that the subject would be finally concluded, and Mr. Crawford once gone from Mansfield, that every thing would soon be as if no such subject had existed. She would not, could not believe, that Mr. Crawford's affection for her could distress him long;

his mind was not of that sort. London would soon bring its cure. In London he would soon learn to wonder at his infatuation, and be thankful for the right reason in her, which had saved him from its evil consequences.

## Example 6

This funny bit from *Uncle Tom's Cabin* consists of a couple of long sentences, loosely connected, in onomatopoeic imitation of the interminable, jolting, chaotic journey the author is writing about. Stowe is not what's called a "great stylist," but she is an absolutely first-rate storyteller. Her prose does what she wants it to and carries us right along with it.

### Harriet Beecher Stowe: from *Uncle Tom's Cabin*

Over such a road as this our senator went stumbling along, making moral reflections as continuously as under the circumstances could be expected, — the carriage proceeding along much as follows, — bump! bump! bump! slush! down in the mud! — the senator, woman, and child, reversing their positions so suddenly as to come, without any very accurate adjustment, against the windows of the down-hill side. Carriage sticks fast, while Cudjoe on the outside is heard making a great muster among the horses. After various ineffectual pullings and twitchings, just as the senator is losing all patience, the carriage suddenly rights itself with a bounce, — two front wheels go down into another abyss, and senator, woman, and child, all tumble promiscuously on to the front seat, — sena-

tor's hat is jammed over his eyes and nose quite unceremoniously, and he considers himself fairly extinguished; — child cries, and Cudjoe on the outside delivers animated addresses to the horses, who are kicking, and floundering, and straining under repeated cracks of the whip. Carriage springs up, with another bounce, — down go the hind wheels, — senator, woman, and child, fly over on to the back seat, his elbows encountering her bonnet, and both her feet being jammed into his hat, which flies off in the concussion. After a few moments the "slough" is passed, and the horses stop, panting; — the senator finds his hat, the woman straightens her bonnet and hushes her child, and they brace themselves for what is yet to come.

## Example 7

This beautiful passage from *Huckleberry Finn* could exemplify a lot of things, but let's use it as an example of a very long sentence, consisting of short or fairly short subsentences strung together by semicolons, which catches the rhythm and even the voice quality of a person talking aloud — quietly. You can't orate this passage, you can't belt it out. It has its own voice: Huck's voice, which is understated and totally unassuming. It's calm, gentle, singsong. It flows, as quiet as the river and as sure as the coming of day. The words are mostly short and simple. There's a bit of syntax that the grammarians would call "incorrect," which snags up and flows on just exactly like the snag and the water that it describes. There's some dead fish, and then the sun rises, and it's one of the great sunrises in all literature.

## Mark Twain: from *The Adventures of Huckleberry Finn*

... then we set down on the sandy bottom where the water was about knee deep, and watched the daylight come. Not a sound anywheres — perfectly still — just like the whole world was asleep, only sometimes the bull-frogs a-cluttering, maybe. The first thing to see, looking away over the water, was a kind of dull line — that was the woods on t'other side — you couldn't make nothing else out; then a pale place in the sky; then more paleness, spreading around; then the river softened up, away off, and warn't black any more, but gray; you could see little dark spots drifting along, ever so far away — trading scows, and such things; and long black streaks — rafts; sometimes you could hear a sweep screaking; or jumbled-up voices, it was so still, and sounds come so far; and by-and-by you could see a streak on the water which you know by the look of the streak that there's a snag there in a swift current which breaks on it and makes that streak look that way; and you see the mist curl up off of the water, and the east reddens up, and the river, and you make out a log cabin in the edge of the woods, away on the bank on t'other side of the river, being a woodyard, likely, and piled by them cheats so you can throw a dog through it anywheres; then the nice breeze springs up, and comes fanning you from over there, so cool and fresh, and sweet to smell, on account of the woods and the flowers; but sometimes not that way, because they've left dead fish laying around, gars, and such, and they do get pretty rank; and next you've got

the full day, and everything smiling in the sun, and the song-birds just going it!

## Example 8

In this passage listen to the variety of sentence length, the complexity of the syntax, including the use of parentheses, and the rhythm thus obtained, which flows and breaks, pauses, flows again — and then, in a one-word sentence, stops.

### Virginia Woolf: from "Time Passes" in *To the Lighthouse*

Then indeed peace had come. Messages of peace breathed from the sea to the shore. Never to break its sleep any more, to lull it rather more deeply to rest, and whatever the dreamers dreamt holily, dreamt wisely, to confirm — what else was it murmuring — as Lily Briscoe laid her head on the pillow in the clean still room and heard the sea. Through the open window the voice of the beauty of the world came murmuring, too softly to hear exactly what it said — but what mattered if the meaning were plain? entreating the sleepers (the house was full again; Mrs. Beckwith was staying there, also Mr. Carmichael), if they would not actually come down to the beach itself at least to lift the blind and look out. They would see then night flowing down in purple; his head crowned; his sceptre jewelled; and how in his eyes a child might look. And if they still faltered (Lily was tired out with travelling and slept almost at once; but Mr. Carmichael read a book by

candlelight), if they still said no, that it was vapour, this splendour of his, and the dew had more power than he, and they preferred sleeping; gently then without complaint, or argument, the voice would sing its song. Gently the waves would break (Lily heard them in her sleep); tenderly the light fell (it seemed to come through her eyelids). And it all looked, Mr. Carmichael thought, shutting his book, falling asleep, much as it used to look.

Indeed, the voice might resume, as the curtains of dark wrapped themselves over the house, over Mrs. Beckwith, Mr. Carmichael, and Lily Briscoe so that they lay with several folds of blackness on their eyes, why not accept this, be content with this, acquiesce and resign? The sigh of all the seas breaking in measure round the isles soothed them; the night wrapped them; nothing broke their sleep, until, the birds beginning and the dawn weaving their thin voices in to its whiteness, a cart grinding, a dog somewhere barking, the sun lifted the curtains, broke the veil on their eyes, and Lily Briscoe stirring in her sleep. She clutched at her blankets as a faller clutches at the turf on the edge of a cliff. Her eyes opened wide. Here she was again, she thought, sitting bolt upright in bed. Awake.

## FURTHER READING

Virginia Woolf's thought and work is wonderful in itself and useful to anyone thinking about how to write. The rhythm of Woolf's prose is to my ear the subtlest and strongest in English fiction.

She said this about it, in a letter to a writer friend:

Style is a very simple matter; it is all rhythm. Once you get that, you can't use the wrong words. But on the other hand here am I sitting after half the morning, crammed with ideas, and visions, and so on, and can't dislodge them, for lack of the right rhythm. Now this is very profound, what rhythm is, and goes far deeper than words. A sight, an emotion, creates this wave in the mind, long before it makes words to fit it.

I've never read anything that says more about the mystery at the very center of what a writer does.

Patrick O'Brian's series of sea novels (it begins with *Master and Commander*) contains sentences so marvelously clear, vivid, and fluent that one can't believe they're as long as they are. Gabriel García Márquez experiments with nonstop sentences and with omission of paragraphing in several of his novels. For short-short sentences, or long ones built up from short ones strung together with *and,* you might look at Gertrude Stein, or Ernest Hemingway, who learned a lot from Stein.

~~~~~~~~~~~~~~~~~~~~

## EXERCISE THREE: Short and Long

**Part One:** Write a paragraph of narrative, 100–150 words, in sentences of seven or fewer words. No sentence fragments!* Each must have a subject and a verb.

**Part Two:** Write a half page to a page of narrative, up to 350 words, that is all one sentence.

*Suggested subjects:* For Part One, some kind of tense, intense action — like a thief entering a room

where someone's sleeping. For Part Two: A very long sentence is suited to powerful, gathering emotion and to sweeping a lot of characters in together. You might try some family memory, fictional or real, such as a key moment at a dinner table or at a hospital bed.

~~~~~~~~~~~~~~~~~~~~~~

*Note:* Short sentences don't have to consist of short words; long sentences don't have to consist of long ones.

***In critiquing,*** it may be interesting to discuss how well the short or long sentences fit the story being told. Do the short sentences read naturally? How is the long sentence constructed — in carefully articulated pieces or one torrent? Is the syntax of the long sentence clear and assured, so that the reader doesn't get lost and have to go back and start over? Does it read easily?

***To think or talk about after writing:*** If either part of the exercise forced you into writing in a way you'd never ordinarily choose to write, consider whether this was enjoyable, useful, maddening, enlightening, etc., and why.

If this exercise has interested you in sentence length as a very important element of prose style, you might want to work on it some more.

~~~~~~~~~~~~~~~~~~~~~~

## *Optional Revisits to EXERCISE THREE*

**Part One:** If you wrote the exercise the first time in an authorial or formal voice, try the same or a different

subject in a colloquial,* even a dialect voice — perhaps a character talking to another character.

If you did it colloquially to start with, back off a little and try a more detached, authorial mode.

**Part Two:** If your long sentence was syntactically simple, connected mainly with *and*s or semicolons, try one with some fancy clauses and stuff — show Henry James how.

If you already did that, try a more "torrential" mode, using *and*s, dashes, etc. — let it pour out!

**Both parts:** If you told two different stories in the two different sentence lengths, you might try telling the same story in both and see what happens to the story.

~~~~~~~~~~~~~~~~~~~~

The *paragraph* should come here, because, like the sentence, it's a key element in the ordering and articulation of the narrative as a whole. However, an exercise in paragraphing would have to be pages long before it could be useful. And important as paragraphing is, it's hard to discuss in the abstract.

It's always something to keep in mind when revising. It matters where you put those little indents. They show connections and separations in the flow; they are architecturally essential, part of the structure and the long rhythmic pattern of the work.

The following is rather tendentious, so I set it as

## AN OPINION PIECE ON PARAGRAPHING

I have found in several how-to-write books statements such as "Your novel should begin with a one-sentence paragraph," "No paragraph in a story should contain more than four sentences," and so on. Rubbish! Such "rules" probably originated in periodicals printed in columns — newspapers, pulp magazines, *The New Yorker* — which have to break the tight gray density of the print with frequent indents, large initial caps, and line breaks. If you publish in such periodicals, expect to let the editors add breaks and paragraph indents. But you don't have to do it to your own prose.

"Rules" about keeping paragraphs and sentences short often come from the kind of writer who boasts, "If I write a sentence that sounds literary, I throw it out," but who writes his mysteries or thrillers in the stripped-down, tight-lipped, macho style — a self-consciously literary mannerism if there ever was one.

*The sudden wind brought rain,*
*a cold rain on a cold wind.*

# 4. repetition

JOURNALISTS AND SCHOOLTEACHERS
mean well, but they can be fatally bossy. One of their
strangely arbitrary rules forbids us to use the same word twice
on the same page. Thus they drive us to the thesaurus in desper-
ate searches for far-fetched synonyms and substitutes.

The thesaurus is invaluable when your mind goes blank on
the word you need or when you really *must* vary the word choice
— but use it discreetly. The Dictionary Word, the word that re-
ally isn't your word, may stick out of your prose like a flamingo in
a flock of pigeons, and it will change the tone. "She'd had enough
cream, enough sugar, enough tea" isn't the same as "She'd had

enough cream, an ample sufficiency of sugar, and a plenitude of tea."

Repetition is awkward when it happens too often, emphasizing a word for no reason: "He was studying in his study. The book he was studying was Plato." This kind of childish echo occurs when you aren't rereading as you write. Everybody does it now and then. It's easy to fix in revision by finding a synonym or a different phrasing: "He was in his study, reading Plato and making notes," or whatever.

But to make a rule never to use the same word twice in one paragraph, or to state flatly that repetition is to be avoided, is to go right against the nature of narrative prose. Repetition of words, of phrases, of images; repetition of things said; near-repetition of events; echoes, reflections, variations: from the grandmother telling a folktale to the most sophisticated novelist, all narrators use these devices, and the skillful use of them is a great part of the power of prose.

Prose can't rhyme and chime and repeat a beat as poetry can, or if it does it had better be subtler about it than the first half of this sentence. The rhythms of prose — and repetition is the central means of achieving rhythm — are usually hidden or obscure, not obvious. They may be long and large, involving the whole shape of a story, the whole course of events in a novel: so large they're hard to see, like the shape of the mountains when you're driving on a mountain road. But the mountains are there.

## Example 9

"The Thunder Badger" is sacred or ritual narrative, an oral form

that predates the distinction of prose from poetry. All such narration is completely fearless about repetition, using it openly and often, both to shape the story and to give the words their due majesty and power, as in an incantation. This Paiute story isn't heavy-duty sacred, just ordinarily sacred. It should be told, like most stories, only in the winter. I apologize for retelling it out of season. It really must be read aloud.

### "The Thunder Badger," from W. L. Marsden, *Northern Paiute Language of Oregon,* a word-by-word translation, slightly adapted by U.K.L.

He, the Thunder, when he is angry that the earth has dried up, that he has no moist earth, when he wants to make the earth moist, because the water has dried up:

He, the Thunder, the Rain Chief, lives on the surface of the clouds. He has frost; he, the Thunder Sorcerer, appears like a badger; the Rain Sorcerer, he, the Thunder. After he digs, he lifts up his head to the sky, then the clouds come; then the rain comes; then there is cursing of earth; the thunder comes; the lightning comes; evil is spoken.

He, the real badger, only he, white stripes on his nose, here on his back. He it is, only the badger, this kind. He, the Thunder Sorcerer, that does not like dried-up earth when he is digging, when he is scratching this way. Then raising his head to the sky, he makes the rain; then the clouds come.

Folktales often repeat themselves exuberantly, both in the language and in the structure: consider "The Three Bears," with its cascade of European triads. (Things in Europe happen in threes,

things in Native American folktales more often in fours.) Stories written to read aloud to children use a lot of repetition. Kipling's *Just So Stories* (see Example 1) are a splendid example of repetition used as incantation, as a structural device, and to make you and the child laugh.

Repetition is often funny. The first time David Copperfield hears Mr. Micawber say, "Something is certain to turn up," it doesn't mean much to David or to us. By the time we've heard Mr. Micawber, forever hopeful in his incompetence, say the same or nearly the same words throughout the long book, it is very funny. The reader waits for it, as for the inevitable and delightful repetition of a musical phrase in Haydn. But also, every time Mr. Micawber says it, it means more. It gathers weight. The darkness underneath the funniness grows always a little darker.

In the next example, where a glaringly bright scene sets the mood for a long, dark novel, a single word is repeated like a hammer blow.

## Example 10

### Charles Dickens: from *Little Dorrit*

Thirty years ago Marseilles lay burning in the sun one day. [. . .] Everything in Marseilles, and about Marseilles, had stared at the fervid sky, and been stared at in return, until a staring habit had become universal there. Strangers were stared out of countenance by staring white houses, staring white walls, staring tracts of arid road, staring hills from which verdure was burnt away. The only things to be seen not fixedly staring and glaring were the vines drooping under

their load of grapes. [. . .] The universal stare made the eyes ache. Towards the distant line of Italian coast, indeed, it was a little relieved by light clouds of mist, slowly rising from the evaporation of the sea, but it softened nowhere else. Far away the staring roads, deep in dust, stared from the hillside, stared from the hollow, stared from the interminable plain. Far away the dusty vines overhanging wayside cottages, and the monotonous wayside avenues of parched trees without shade, drooped beneath the stare of earth and sky.

Repetition of course isn't limited to words or phrases. Structural repetition is the similarity of the events in a story: happenings that echo one another. It involves the whole of a story or novel. For a marvelous example of it, you might reread the first chapter of *Jane Eyre* and think about the rest of the book as you do. (If you haven't read *Jane Eyre*, do; then you can think about it for the rest of your life.) The first chapter is full of foreshadowing — the introduction of images and themes that will return throughout the book. For example, we meet Jane as a shy, silent, self-respecting child, the outsider in an unloving household, who takes refuge in books, pictures, and nature. An older boy who bullies and abuses her goes too far at last, and she turns on him and fights back. Nobody takes her part, and she's locked in an upstairs room that she's been told is haunted. Well, grown-up Jane is going to be the shy outsider in another household, where she'll stand up against Mr. Rochester's bullying, finally be forced to rebel, and find herself utterly alone. And there's an upstairs room in that house which is truly haunted.

The first chapters of many great novels bring in an amazing

amount of material that will be, in one way and another, with variations, repeated throughout the book. The similarity of this incremental repetition of word, phrase, image, and event in prose to recapitulation and development in musical structure is real and deep.

~~~~~~~~~~~~~~~~~~~~~

## EXERCISE FOUR, PARTS 1 AND 2:
# Again and Again and Again

I can't suggest "plots" for these; the nature of the exercise doesn't allow it.

**Part One:** Verbal Repetition

Write a paragraph of narrative (150 words) that includes at least three repetitions of a noun, verb, or adjective (a noticeable word, not an invisible one like *was, said, did*).

~~~~~~~~~~~~~~~~~~~~~

(This is a good exercise for in-class writing. When you read it aloud, don't tell people what the repeated word is; do they hear it?)

~~~~~~~~~~~~~~~~~~~~~

**Part Two:** Structural Repetition

Write a short narrative (350–1000 words) in which something is said or done and then something is said

or done that echoes or repeats it, perhaps in a different context, or by different people, or on a different scale.

This can be a complete story, if you like, or a fragment of narrative.

~~~~~~~~~~~~~~~~~~~~~~

*In critiquing,* you might concentrate on the effectiveness of the repetitions and their obviousness or subtlety.

*To think or talk about after writing:* Were you comfortable at first with the idea of deliberately repeating words and constructions and events? Did you get more comfortable with it while doing it? Did the exercise bring out any particular feeling-tone or subject matter or style in your work, and can you say what it was?

I'm not sure how free the nonfiction writer is to use structural repetition. To force unlike events into a repetitive pattern certainly would be cheating. But to be aware of an existing pattern in the events of a life surely is one of the memoirist's goals.

Look for examples of structural repetition in fiction and nonfiction. An awareness of how repetition, foreshadowing, and echoing contribute to the structure and impetus of narrative can add greatly to your appreciation of a good story.

*We completed the voyage without succumbing to*
*the temptation of opening the box of candy.*

# 5. adjectives and adverbs

ADJECTIVES AND ADVERBS ARE RICH AND good and nourishing. They add color, life, immediacy. They cause obesity in prose only when used lazily or overused.

When the quality that the adverb indicates can be put in the verb itself (*they ran quickly = they raced*) or the quality the adjective indicates can be put in the noun itself (*a growling voice = a growl*), the prose will be cleaner, more intense, more vivid.

Those of us who were brought up to be unaggressive in conversation are liable to use qualifiers — adjectives and adverbs such as *rather, a little,* which soften or weaken the words they modify. In conversation they're OK; in written prose they're bloodsuckers — ticks. You have to dig them out right away. The

ticks I myself am plagued by are *kind of, sort of,* and *just* — and always, always *very.* You might just kind of take a little look at your own writing to see if you might have some very favorite qualifiers that you kind of, like, use just a little too often.

This isn't long enough to be an opinion piece, and you must pardon my language, but it needs saying at this time: the adjective or qualifier *fucking* is a *really big tick.* People who use it constantly in speaking and electronic messaging may not realize that in writing fiction it's about as useful as *umm.* In dialogue and interior monologue, sentences such as "The sunset was so fucking beautiful" or "It's so easy even a fucking child could understand it" are tolerable, however grotesque when read literally. But used in narrative to lend emphasis and colloquial vigor, the word does just the opposite. In fact its power to weaken, trivialize, and invalidate is stunning.

Some adjectives and adverbs have become meaningless through literary overuse. *Great* seldom carries the weight it ought to carry. *Suddenly* seldom means anything at all; it's a mere transition device, a noise — "He was walking down the street. Suddenly he saw her." *Somehow* is a super-weasel, a word that betrays that the author didn't want to bother thinking out the story — "Somehow she just knew . . ." "Somehow they made it to the asteroid." Nothing in your story happens "somehow." It happens because you wrote it. Take responsibility!

Ornate, fancy adjectives are out of fashion and tempt few writers now, but some conscious prose stylists use adjectives as poets do: the adjective's relation to the noun is unexpected, far-fetched, forcing the reader to stop to see the connection. This mannerism can be effective, but in narration it's risky. Do you want to stop the flow? Is it worth it?

I recommend to all storytellers a watchful attitude and a thoughtful, careful choice of adjectives and adverbs, because the bakery shop of English is rich beyond belief, and narrative prose, particularly if it's going a long distance, needs more muscle than fat.

~~~~~~~~~~~~~~~~~~~~

## EXERCISE FIVE: Chastity

Write a paragraph to a page (200–350 words) of descriptive narrative prose without adjectives or adverbs. No dialogue.

The point is to give a vivid description of a scene or an action using only verbs, nouns, pronouns, and articles.

Adverbs of time (*then, next, later,* etc.) may be necessary, but be sparing. Be chaste.

If you're using this book in a group, I recommend that you do this exercise at home, because it is difficult and may take a while.

If you're currently working on a longer piece, you might want to try writing the next paragraph or page of it as this exercise.

You might want to try "chastening" a passage you've already written. It can be interesting.

~~~~~~~~~~~~~~~~~~~~

***Critiquing:*** It's above all the doing of this exercise that matters, and your own judgment on the result. Would the piece be improved by the addition of an adjective or adverb here and there, or is it satisfactory without? Notice the devices and usages you were forced into by the requirements of the exercise. It may have affected particularly your choice of verbs and your use of simile and metaphor.

I invented the Chastity Exercise for my own use when I was a Lone Navigator of fourteen or fifteen. I couldn't give up chocolate milkshakes, but I could do without adverbs for a page or two. It's the only exercise I've suggested in every workshop I've taught. It enlightens, chastens, and invigorates.

*The old woman dreamed of the past as*
*she navigated the seas of time.*

# 6. verbs: person and tense

IN LANGUAGE, *VERBS* ARE WHAT DO THINGS, the *person* of the verb is who does them (a name or a pronoun), and the *tense* of the verb is when they do it. Some how-to-write books give the impression that verbs do everything, action is all. I don't go along with that, but still, verbs matter. And the person and the tense of the verb matter a lot in telling stories.

## PERSON OF THE VERB*

Nonfiction, except for autobiography, has to be written in the

third person. To write about Napoleon or a bacillus in the first person is to write fiction.

The persons available to fictional narrative are first singular (*I*) and third singular (*she, he*), with limited use of first and third plural (*we, they*). Use of the second person (*you*) in fiction is justifiably rare. Every so often somebody writes a story or novel in the second person under the impression that it hasn't been done before.

Almost all preliterate, sacred, and literary prose narrative before the sixteenth century is in the third person. First-person writing turns up first in Cicero's letters, in medieval diaries and saints' confessions, with Montaigne and Erasmus, and in early travel narratives. In fiction, authors at first felt they had to justify presenting a character in the first person. A letter writer naturally writes *I:* hence the epistolary novel. Since the eighteenth century, fiction written in the first person has been so common that we think little about it, but in fact it's an odd, sophisticated, artificial imaginative process both for the writer and for the reader. Who is this *I?* It isn't the writer, because it's a fictional self; and though *I* the reader may identify with it, it's not me either.

Telling a story in the third person remains the commonest and least troublesome mode. The author uses it to move freely about, telling what *he* did and *she* did, and also what *they* thought.

First-person narrative is the ancestor of narrative in the "limited third person." This is a technical literary term, meaning that the writer limits narration to the point of view of one character. The writer can tell explicitly only what that one character perceives, feels, knows, remembers, or guesses. In other words, it's very like writing in the first person. I'll talk about this in the chapter on point of view, along with the equally important topic

of limited versus multiple third person. It all sounds very technical, but it really is important.

If it comes up at all, the choice of whether to write a piece of fiction in first person or third person is a big one. Sometimes you never have to give a thought to what person to tell a story in. But sometimes a story you start telling as *I* gets stuck, and what it needs is to get out of the first person; sometimes a story that starts out with *he said* or *she went* needs to get out of the third person into the *I* voice. When a story keeps sticking or gets stuck, keep the possibility of that change of person in mind.

## FURTHER READING

First-person narration, however tricky, is so common both in fiction and in memoir that I hesitate to single out any book or books from the thousands of excellent examples of it. But I do urge you to read anything written by Grace Paley. Her stories avoid all the pitfalls of first-person narration — posing, egotism, self-consciousness, monotony. They seem like artless little things — just some woman telling you about something. They are masterpieces of art.

And again, so many modern stories and novels are told in the limited third person that recommendation becomes arbitrary. But I recommend that, for a while at least, you notice what person(s) the book you're reading is written in, and whether and when and how it changes person.

## TENSES* OF THE VERB

The past tense (*she did it, he was there*) and the present tense

(*she does it, he is there*) are both capable of variations expressing such things as continuity of action and how events relate in time (*she was making a living before he'd even begun looking for a job*). Priority or subsequence in time is easy to express in the past tense, but the present tense is less flexible, tending to cling to the present (*she is making a living before he even begins to look for a job*).

Abstract discourse is always in the present tense (I'm writing it right now). Generalities aren't time-bound, and so philosophers, physicists, mathematicians, and God all speak in the present tense.*

Screenplays appear to be in the present tense, but they're actually in the imperative voice: they're instructions — they say what *is to happen* onscreen. "Dick grins at Jane, fires. Blood spatters lens. CU: Spot falls dead." These aren't descriptions. They tell the actors, cameraman, ketchup person, dog, and everybody else what to do.

We use the present tense above all in talking, in conversation: "How are you? — I'm fine, thanks." As soon as we start narrating, we tend naturally to drop into the past tense: "What happened?" — "I backed into a car that was backing out of where it was parked." Eyewitness narration is of course in the present tense: "Oh, my God, it's catching fire!" or "He's crossing the fifty-yard line, he's in the clear now!" — or in the communication

---

* Seeking equal authority, anthropologists used to write, "The Ussu worship forest spirits," ignoring the fact that the last three living Ussu were Mormon converts working for a lumber mill: an example of how ethical issues can get attached to something that seems as utterly value-neutral as a verb tense. "The misuse of language induces evil in the soul."

that tells you about the tasty *fugu* fish your friend is eating as he tweets to you just before he dies in agony.

For several thousand years, stories were told and written mainly in the past tense(s), with an occasional dramatic passage in what was then called "the historical present." For the past thirty years or so, many writers have been using only the present tense for narratives, fictional and nonfictional. By now the present tense is so omnipresent that young writers may think it's obligatory. A very young one said to me, "The old dead writers lived in the past, so they couldn't write in the present, but we can." Evidently the mere name, "present tense," leads people to assume that it's about now and that the past tense is about long ago. This is awfully naive. Verb tenses have so little connotation of actual presentness or pastness that they are in most respects interchangeable.

The thing to remember is that, after all, a written story, whether it's imaginary or based on real events, exists only on the page. Both present-tense and past-tense narration are *totally fictive.*

Present-tense narration persuades people that it's "more real" because it sounds like eyewitness narration. And the reason most writers give for using it is that it's "more immediate." Some justify it aggressively: "We live in the present, not the past."

Well, to live in the present only would be to live in the world of newborn infants or of people who have lost their long-term memory. Living in the present isn't all that easy for most of us. Being present in the present, really living in it, is one of the goals of awareness meditation, which people practice for years. Being human, we spend most of the time with our head full of what is

*not* right here right now — thinking about this, wondering about that, remembering something, planning to do something else, talking to somebody somewhere on a cell phone, texting somebody else — and only occasionally trying to put it all together to become aware of, to make sense of, the present moment.

I see the big difference between the past and present tenses not as immediacy but as complexity and size of field. A story told in the present tense is necessarily focused on action in a single time and therefore a single place. Use of the past tense(s) allows continual referring back and forth in time and space. That's how our minds normally work, moving around easily. Only in emergency situations do they focus very tightly on what's going on. And so narration in the present tense sets up a kind of permanent artificial emergency, which can be exactly the right tone for fast-paced action.

The past tense can also focus tightly, but it always gives access to time before and after the moment of the narrative. The moment it describes is a moment continuous with its past and its future.

The difference is like the difference between a narrow-beam flashlight and sunlight. One shows a small, intense, brightly lit field with nothing around it; the other shows the world.

The quality of limitation may attract a writer to the present tense. Its tightly focused beam of attention affords the writer and reader the detachment of visible artifice. It brings the field very close, like a microscope, yet distances by eliminating the surround. It cuts out, minimizes. It keeps the story cool. It can be a wise choice for a writer whose engine is liable to overheat. It also reflects the huge influence of film (not screenplay) on our imaginations. Excellent writers (James Tiptree, Jr. among them)

have said that they *see* the action of the story as they write it, exactly like a film, so their use of the present tense is a kind of imaginary eyewitness reporting.

These limitations and implications of present-tense narration are worth thinking about.

The novelist Lynne Sharon Schwartz argued that present-tense narration, avoiding temporal context and historical trajectory, oversimplifies, suggesting that nothing "is terribly complex and that understanding, such as it is, can be achieved by naming objects or accumulating data," and that "all we can ever understand is what can be understood from a glimpse." This externality and narrowness of its field of vision may be why so much present-tense narrative sounds cool — flat, unemotional, uninvolved. And therefore all rather alike.

I suspect some people write in the present tense because they're afraid not to. (She had had some trouble with the past-perfect tense in an earlier life. In her next life, she will not be going to have any trouble with the future-perfect tense. But she would have liked never to have had any trouble at all.) You may not have learned all the fancy names for the various tenses, but don't worry. You know how to do it. All that stuff is in your head, and has been ever since you learned to say "I went" instead of "I goed."*

---

* At the beginning of one of my books I wrote, "The people in this book might be going to have lived a long, long time from now in Northern California." That is — I think — the active voice, progressive conjugation, potential mood, present tense, third-person plural of *go* inflecting the past infinitive of *live*.

I deliberately used this magnificent conglomeration of verbiage to establish myself and the reader as pretending to look back in time on some

If you always write (and read) in present tense, some of the verb forms in your head may not have been activated for a long time. To regain free use of them is to increase your range of options as a storyteller. All art involves limitation; but a writer who uses only one tense seems a bit like a painter who, out of a whole set of oil paints, uses only pink.

My general point is this: at the moment the present tense is in fashion; but if you're not comfortable with it, don't let yourself be crowded into using it. For some people and some stories it's right, for others not. The choice is important, and entirely up to you.

## ON TWO-TIMING

I could almost state this as a rule, but I won't, because good and careful writers will blow all Rules of Writing into bits. So I state it as a High Probability.

It is highly probable that if you *keep changing the tense* of your narrative, if you go back and forth between past and present tense frequently and without some kind of signal (a line break, a dingbat,* a new chapter) — your reader will get all mixed up and

---

fictional people whom we are at the same time pretending might exist in a time far in our future. You can say all that with a couple of verb forms.

The copy editor was amazingly civil about my grand verb. One reviewer apparently was unable to get to the end of it, and whined about it. Others cited it with what I hope was amusement or admiration. I still like it. It was the shortest way to say exactly what I meant. That's what verbs, in all their moods and tenses, are for.

will not know what happened before what and what's happening after what and when we are, or were, at the moment.

Such confusions can occur even when writers switch tenses deliberately. When they do it without knowing they're doing it, when they're simply unconscious of what tense they're writing in and go flipping from present to past to present, it is highly probable that the reader will not understand what happened, let alone when, and will end up seasick, sullen, and indifferent.

The following short passage is from a modern novel. Not wanting to embarrass the author, I change names and actions to make the scene unrecognizable, but I reproduce the syntax and the verb numbers and tenses exactly.

> They both come in wanting coffee. We hear Janice playing the TV in the other room. I noticed Tom had a black eye that I didn't see last night. "Did you go out?" I said.
>
> Tom sits down with the paper and says nothing. Alex says, "We both went out."
>
> I drank two cups of coffee before I said anything.

Is it possible to read this without noticing that it changes tense three times in six lines? (To be exact, it changes tense five times, since the simple past "I didn't see" refers to a time previous to the present, but it occurs in a past-tense sentence, where a previous time would normally be indicated by the past-perfect, "I hadn't seen.") Is it possible to say that anything is gained by this incoherence, which continues throughout the book? I can't believe that the author was even aware of it. But that's an awful thing to say.

A tense switch in written narrative isn't a minor thing. It's a big deal, like changing viewpoint characters. It can't be done mindlessly. It can be done invisibly, but only if you know what you're doing.

So make sure, if you change tenses in midstory, that you know you're doing it, and why. And if you do it, make sure you carry your readers effortlessly with you, and don't maroon them, like the hapless crew of the *Enterprise,* in a Temporal Anomaly that they can get out of only by using Warp Speed Ten.

## OPINION PIECE ON THE PASSIVE VOICE

I introduced this topic in chapter 2, p. 16, talking about Fake Rules. Many verbs have an active and a passive voice. To change the voice reverses the subject and object of the verb. Active: *She hit him.* Passive: *He was hit by her.*

Passive constructions, such as those used in the sentence presently being read by you, are far too frequently employed in the writing of academic papers and business correspondence; those whose efforts have been to see this usage reduced are to be commended by all those by whom English is spoken. (Now rewrite that paragraph in the active voice!)

Too many people who yatter on about "you should never use the passive voice" don't even know what it is. Many have confused it with the verb *to be,* which grammarians so sweetly call "the copulative" and which doesn't even have a passive voice. And so they go around telling us not to use the verb *to be!* Most verbs are more exact and colorful than that one, but you tell me how else Hamlet should have started his soliloquy, or how Jehovah should have created light.

"It was proposed that the motion be tabled by the committee." Two passives.

"Ms. Brown proposed that the committee hang the chairman." Two actives.

People often use the passive voice because it's indirect, polite, unaggressive, and admirably suited to making thoughts seem as if nobody had personally thought them and deeds seem as if nobody had done them, so that nobody need take responsibility. Writers who want to take responsibility are wary of it. The cowardly writer says, "It is believed that being is constituted by ratiocination." The brave writer says, "I think, therefore I am."

If your style has been corrupted by long exposure to academese or scientific or "business English," you may need to worry about the passive. Make sure it hasn't seeded itself where it doesn't belong. If it has, root it out as needed. Where it does belong, we ought to use it freely. It is one of the lovely versatilities of the verb.

*Example: See Number 12, on p. 77*

One of the examples for the next chapter, from Charles Dickens's *Bleak House,* is also the example for this one, because it dramatically demonstrates *changes of both person and tense* within a narrative. Dickens of course doesn't two-time us — he knows exactly what tense he's using when, and why. But he does something very risky. Right through the long book, he switches back and forth — one chapter is in the third-person present tense, the next in the first-person past tense. Even in Dickens's hands this alternation causes some awkwardness. But it's very interesting to see how it works and when it doesn't, and to compare the dif-

ferent effects. It's where I first got the idea that the present tense affords intense focus and detached affect* while past-tense narration gives a better sense of the continuity, variety, and depth of experience.

The exercise is intended to bring out the difference a change of person and tense can make.

~~~~~~~~~~~~~~~~~~~~~

## EXERCISE SIX: The Old Woman

This should run to a page or so; keep it short and not too ambitious, because you're going to write the same story twice.

The subject is this: An old woman is busy doing something—washing the dishes, or gardening, or editing a PhD dissertation in mathematics, whatever you like—as she thinks about an event that happened in her youth.

You're going to *intercut* between the two times. "Now" is where she is and what she's doing; "then" is her memory of something that happened when she was young. Your narration will *move back and forth* between "now" and "then."

You will make *at least two* of these moves or time jumps.

~

**Version One:** PERSON: Choose either first person (*I*) or third person (*She*). TENSE: Tell it all in the past tense or all in the present tense. Make the shifts between "now" and "then" in her mind clear to the reader — don't two-time us — but be subtle about it if you can.

**Version Two:** Write the same story. PERSON: Use the person of the verb you didn't use in Version One. TENSE: Choose: a) present tense for "Now," past tense for "Then," OR b) past tense for "now," present tense for "then."

Don't try to keep the wording of the two versions identical. Don't just go through it on your computer changing the pronoun and the verb endings. Write it over! Changing the person and tense will bring about some changes in the wording, the telling, the feeling of the piece, and that's what the exercise is all about.

*Additional option:* If you want to go on and play with other person/tense options, do.

~~~~~~~~~~~~~~~~~~~~~~~~~

*Critiquing:* Consider the ease or awkwardness of the time shifts; how well suited the tenses chosen are to the material; which pronoun and which choice or combination of tenses worked best for this story; whether there's much difference between the two versions and if there is, what it is.

***To think or talk about after writing:*** Were you more at ease writing past or present tense? First or third person? Why?

It can be useful to read narrative prose with a particular consciousness of what persons and tenses of the verb are used, why the author may have used them, how well they're used, what effect they give, whether and how often and why the narrative tense is changed.

*I saw that he was lost in his memories, like a
boat that drifts on its own reflection.*

# 7. point of view and voice

POINT OF VIEW (POV FOR SHORT) IS THE
technical term for *who is telling the story and what their
relation to the story is.*

This person, if a character in the story, is called the *viewpoint
character.* The only other person it can be is the author.

*Voice* is a word critics often use in discussing narrative. It's
always metaphorical, since what's written is voiceless until read
aloud. Often *voice* is a kind of shorthand for authenticity (writing in your own voice, catching the true voice of a person, and so
on). I'm using it naively and pragmatically to mean *the voice or
voices that tell the story,* the narrating voice. In this book, at this

point, I'll treat voice and point of view as so intimately involved and interdependent as to be the same thing.

## THE PRINCIPAL POINTS OF VIEW

What follows is my attempt to define and describe the five principal narrative points of view. Each description is followed by an example: a paragraph told in that POV, from a nonexistent story called "Princess Sefrid." It's the same scene each time, the same people, the same events. Only the viewpoint changes.

### A Note on the "Reliable Narrator"

In autobiography and memoir — in nonfiction narrative of any kind — the *I* (whether the writer uses it or not) is the author. In these forms, we normally expect the author/narrator to be reliable: to try honestly to tell us what they think happened — not to invent, but to relate.

The immense difficulty of relating facts honestly has been used to justify the choice not to relate facts honestly. Some nonfiction writers, claiming fiction's privilege of invention, deliberately alter facts in order to present a "truth" superior to what merely happened. The memoirists and nonfiction writers I respect are fully aware of the impossibility of being perfectly factual, and wrestle with it as with an angel, but never use it to excuse lying.

In fiction, however autobiographical-confessional it may be, the narrator is by definition fictive. All the same, most narrators, first or third person, in serious fiction used to be trustworthy. But our shifty age favors "unreliable narrators" who — deliberately or innocently — misrepresent the facts.

The motivation here is very different from that of the dishonest nonfiction writer. Fictional narrators who suppress or distort facts or make mistakes in relating or interpreting the events are almost always telling us something about themselves (and perhaps about us). The author lets us see or guess what "really" happened, and using this as a touchstone, we readers are led to understand how other people see the world, and why they (and we?) see it that way.

A familiar example of a semireliable narrator is Huck Finn. Huck is an honest person, but he misinterprets a good deal of what he sees. For instance, he never understands that Jim is the only adult in his world who treats him with love and honor, and he never really understands that he loves and honors Jim. The fact that he can't understand it tells us an appalling truth about the world he and Jim — and we — live in.

Princess Sefrid, as you will see by comparing her relation with those of other viewpoint characters, is entirely reliable.

## First Person

In first-person narration, the viewpoint character is "I." "I" tells the story and is centrally involved in it. Only what "I" knows, feels, perceives, thinks, guesses, hopes, remembers, etc., can be told. The reader can infer what other people feel and who they are only from what "I" sees, hears, and says of them.

### Princess Sefrid: First-Person Narration

I felt so strange and lonesome entering the room crowded with strangers that I wanted to turn around and run, but Rassa

was right behind me, and I had to go ahead. People spoke to me, asked Rassa my name. In my confusion I couldn't tell one face from another or understand what people were saying to me and answered them almost at random. Only for a moment I caught the glance of a person in the crowd, a woman looking directly at me, and there was a kindness in her eyes that made me long to go to her. She looked like somebody I could talk to.

## Limited Third Person

The viewpoint character is "he" or "she." "He" or "she" tells the story and is centrally involved in it. Only what the viewpoint character knows, feels, perceives, thinks, guesses, hopes, remembers, etc., can be told. The reader can infer what other people feel and are only from what the viewpoint character observes of their behavior. This limitation to the perceptions of one person may be consistent throughout a whole book, or the narrative may shift from one viewpoint character to another. Such shifts are usually signaled in some way, and usually don't happen at very short intervals.

Tactically, limited third is identical to first person. It has exactly the same essential limitation: that nothing can be seen, known, or told except what the narrator sees, knows, and tells. That limitation concentrates the voice and gives apparent authenticity.

It seems that you could change the narration from first to limited third person by merely instructing the computer to switch the pronoun, then correct verb endings throughout, and voilà. But it isn't that simple. First person is a different voice from limited third. The reader's relationship to that voice is different

— because the author's relationship to it is different. Being "I" is not the same as being "he" or "she." In the long run, it takes a quite different imaginative energy, both for the writer and for the reader.

There is no guarantee, by the way, that the limited third-person narrator is reliable.

Stream of consciousness* is a particularly inward form of limited third person.

### Princess Sefrid: Limited Third Person

Sefrid felt isolated, conspicuous, as she entered the room crowded with strangers. She would have turned around and run back to her room, but Rassa was right behind her, and she had to go ahead. People spoke to her. They asked Rassa her name. In her confusion she could not tell one face from another or understand what people said to her. She answered them at random. Only once, for a moment, a woman looked directly at her through the crowd, a keen, kind gaze that made Sefrid long to cross the room and talk to her.

## Involved Author ("Omniscient Author")

The story is not told from within any single character. There may be numerous viewpoint characters, and the narrative voice may change at any time from one to another character within the story, or to a view, perception, analysis, or prediction that only the author could make. (For example, the description of what a person who is quite alone looks like, or the description of a landscape or a room at a moment when there's nobody there

to see it.) The writer may tell us what anyone is thinking and feeling, interpret behavior for us, and even make judgments on characters.

This is the familiar voice of the storyteller, who knows what's going on in all the different places the characters are at the same time, and what's going on inside the characters, and what has happened, and what has to happen.

All myths and legends and folktales, all young children's stories, almost all fiction until about 1915, and a vast amount of fiction since then use this voice.

I don't like the common term "omniscient author," because I hear a judgmental sneer in it. I prefer "involved author." "Authorial narration" is a neutral term which I will also use.

Limited third person is the predominant modern fictional voice — partly in reaction to the Victorian fondness for involved-author narration and the many possible abuses of it.

Involved author is the most openly, obviously manipulative of the points of view. But the voice of the narrator who knows the whole story, tells it because it is important, and is profoundly involved with all the characters cannot be dismissed as old-fashioned or uncool. It's not only the oldest and the most widely used storytelling voice, it's also the most versatile, flexible, and complex of the points of view — and probably, at this point, the most difficult for the writer.

### Princess Sefrid: Involved Author ("Omniscient Author")

The Tufarian girl entered the room hesitantly, her arms close to her sides, her shoulders hunched; she looked both fright-

ened and indifferent, like a captured wild animal. The big Hemmian ushered her in with a proprietary air and introduced her complacently as "Princess Sefrid" or "the princess of Tufar." People pressed close, eager to meet her or simply to stare at her. She endured them, seldom raising her head, replying to their inanities briefly, in a barely audible voice. Even in the pressing, chattering crowd she created a space around herself, a place to be lonely in. No one touched her. They were not aware that they avoided her, but she was. Out of that solitude she looked up to meet a gaze that was not curious but open, intense, compassionate — a face that said to her, through the sea of strangeness, "I am your friend."

## Detached Author ("Fly on the Wall," "Camera Eye," "Objective Narrator")

There is no viewpoint character. The narrator is not one of the characters and can say of the characters only what a totally neutral observer (an intelligent fly on the wall) might infer of them from behavior and speech. The author never enters a character's mind. People and places may be exactly described, but values and judgments can only be implied indirectly. A popular voice around 1900 and in "minimalist" and "brand-name" fiction, it is the least overtly, most covertly manipulative of the points of view.

It's excellent practice for writers who expect codependent readers. When we're new at writing, we may expect our readers to respond just as we respond to what we're writing about — to cry because we're crying. But this is a childish, not a writerly, relation to the reader. If you can move a reader while using this cool voice, you've got something really moving going on.

### Princess Sefrid: Detached Author ("Fly on the Wall," "Camera Eye," "Objective Narrator")

The princess from Tufar entered the room, followed closely by the big man from Hemm. She walked with long steps, her arms close to her sides and her shoulders hunched. Her hair was thick and frizzy. She stood still while the Hemmian introduced her, calling her Princess Sefrid of Tufar. Her eyes did not meet the eyes of any of the people who crowded around her, staring at her and asking her questions. None of them tried to touch her. She replied briefly to everything said to her. She and an older woman near the tables of food exchanged a brief glance.

## *Observer-Narrator, Using the First Person*

The narrator is one of the characters but not the principal character — present, but not a major actor in the events. The difference from first-person narration is that the story is not about the narrator. It's a story the narrator witnessed and wants to tell us. Both fiction and nonfiction use this voice.

### Princess Sefrid: Observer-Narrator in First Person

She wore Tufarian clothing, the heavy red robes I had not seen for so long; her hair stood out like a storm cloud around the dark, narrow face. Crowded forward by her owner, the Hemmian slavemaster called Rassa, she looked small, hunched, defensive, but she preserved around herself a space that was all her own. She was a captive, an exile, yet I saw in her young

face the pride and kindness I had loved in her people, and I
longed to speak with her.

## Observer-Narrator, Using the Third Person

This point of view is limited to fiction. The tactic is much the
same as the last one. The viewpoint character is a limited third-
person narrator who witnesses the events.

As unreliability is a complex and subtle way of showing the
narrator's character and the observer-narrator isn't the protago-
nist, the reader is usually safe in assuming that this viewpoint
character is fairly reliable, or at least transparent, both in first
and third person.

### Princess Sefrid: Observer-Narrator in Third Person

She wore Tufarian clothing, the heavy red robes Anna had
not seen for fifteen years. Crowded forward by her owner,
the Hemmian slavemaster called Rassa, the princess looked
small, hunched, defensive, but she preserved around herself
a space that was all her own. She was a captive, an exile, yet
Anna saw in her young face the pride and kindness she had
loved in the Tufarians, and longed to speak with her.

FURTHER READING

Look at a bunch of stories in an anthology or pull down a bunch
of novels from your shelf (from as wide a span of time as pos-
sible) and identify the viewpoint character(s) and the point(s) of
view of the narration. Notice if they change, and if so, how often.

## CONSIDERATIONS ON CHANGING POINT OF VIEW

I'm going into all this detail because the narrative problem I have met most often in workshop stories (and often in published work) is in handling POV: inconsistency and frequent changes of POV.

It's a problem even in nonfiction, when the author starts telling the reader what Aunt Jane was thinking and why Uncle Fred swallowed the grommet. A memoirist doesn't have the right to do this without clearly indicating that Aunt Jane's thoughts and Uncle Fred's motives aren't known facts but the author's guesswork, opinion, or interpretation. Memoirists can't be omniscient, even for a moment.

In fiction, inconsistent POV is a very frequent problem. Unless handled with awareness and skill, frequent POV shifts jerk the reader around, bouncing in and out of incompatible identifications, confusing emotion, garbling the story.

Any shift from one of the five POVs outlined above to another is a dangerous one. It's a major change of voice to go from first to third person, or from involved author to observer-narrator. The shift will affect the whole tone and structure of your narrative.

Shifts within limited third person — from one character's mind to another's — call for equal awareness and care. A writer must be aware of, have a reason for, and be in control of all shifts of viewpoint character.

I feel like writing the last two paragraphs all over again, but that would be rude. Could I ask you to read them over again?

The POV exercises are intended to make you temporarily su-

perconscious, and forever conscious, of what POV you're using and when and how you shift it.

Limited third is, at present, the person most fiction writers are most used to using. First person is, of course, the voice memoirists mostly use. I think it's a good idea for all of us to try all the other possibilities.

Fiction writers are used to writing in other people's voices, being other selves. But memoirists aren't. To use limited third person in factual narrative is to trespass, pretending you know what another real person thought and felt. But there's no problem with pretending you know what somebody you invented thinks and feels. So I recommend that, just for the exercise, memoirists invent a story, make up characters, in the shameless way fiction writers do.

## EXERCISE SEVEN: Points of View

Think up a situation for a narrative sketch of 200–350 words. It can be anything you like but should involve *several people doing something.* (Several means more than two. More than three will be useful.) It doesn't have to be a big, important event, though it can be; but something should *happen,* even if only a cart tangle at the supermarket, a wrangle around the table concerning the family division of labor, or a minor street accident.

Please use little or no dialogue in these POV exercises. While the characters talk, their voices cover the POV, and so you're not exploring that voice, which is the point of the exercise.

**Part One: Two Voices**

First: Tell your little story from a single POV, that of a participant in the event — an old man, a child, a cat, whatever you like. Use limited third person.

Second: *Retell the story* from the POV of one of the other people involved in it. Again, use limited third person.

~~~~~~~~~~~~~~~~~~~~~~~~~~

As we go on into the next parts of this exercise, if your little scene or situation or story runs dry, invent another one along the same lines. But if the original one seems to keep turning up new possibilities in different voices, just go on exploring them through it. That will be the most useful, informative way to do the exercise.

~~~~~~~~~~~~~~~~~~~~~~~~~~

**Part Two: Detached Narrator**

Tell the same story using the detached author or "fly on the wall" POV.

**Part Three: Observer-Narrator**

If there wasn't a character in the original version who was there but was not a participant, only an onlooker,

add such a character now. Tell the same story in that character's voice, in first or third person.

**Part Four: Involved Author**

Tell the same or a new story using the involved-author POV.

Part Four may require you to expand the whole thing, up to two or three pages, 1000 words or so. You may find you need to give it a context, find out what led up to it, or follow it further. The detached author takes up as little room as possible, but the involved author needs a fair amount of time and space to move around in.

If your original story simply doesn't lend itself to this voice, find a story you want to tell that you can be emotionally and morally involved in. I don't mean by that that it has to be factually true (if it is, you may have trouble getting out of the autobiographical mode into the involved author's voice, which is a *fictional* mode). And I don't mean that you should use your story to preach. I do mean that the story should be about something that concerns you.

~~~~~~~~~~~~~~~~~~~~~

*Note: Unspoken Thoughts*

Many writers worry about how to present characters' unspo-

ken thoughts. Editors are likely to put thoughts into italics if you don't stop them.

Thoughts are handled exactly like dialogue, if you present them directly:

> "Heavens," Aunt Jane thought, "he's eating that grommet!"

But in presenting characters' thoughts you don't have to use quotation marks, and using italics or any typographical device can overemphasize the material. Just make it clear that this bit is going on inside somebody's head. Ways of doing so are various:

> As soon as she heard Jim shout, Aunt Jane knew Fred had swallowed the grommet after all.

> I just know he's going to swallow that grommet again, Jane said to herself as she sorted buttons.

> Oh, Jane thought, I do wish the old fool would hurry up and swallow that grommet!

*In critiquing* these exercises in point of view, and in thinking and talking about them later, various strong preferences for certain voices and points of view may come out; it can be interesting to consider and discuss them.

*Later on,* you may want to return to some of these exercises, using the instructions on a different story, perhaps recombining the exercises. The choice of point(s) of view, the voice in which one narrates one's story, can make an immense difference to the tone, the effect, even the meaning of the story. Writers often find that a story they want to tell "sticks" and won't go right until

they find the right person to tell it — whether it's a choice between first and third person, or between the involved author and a limited third-person narrator, or between a character involved in the action and a bystander, or between one and several narrators. The following optional exercises might help bring out the wealth of choices and the necessity of choosing.

~~~~~~~~~~~~~~~~~~~~~~~~~

### *Optional Additions to* EXERCISE SEVEN

Tell a different story, with both versions in the first person instead of limited third.

Or tell the story of an accident twice: once in the detached author mode, or in a journalistic, reportorial voice, then from the viewpoint of a character involved in the accident.

If there's a mode or voice you don't particularly like, that's probably the one you should try again, if only to find out why you dislike it. (I'm sure you'll like your tapioca if you'll just try it, dear.)

~~~~~~~~~~~~~~~~~~~~~~~~~

Because omniscience is out of fashion and some readers aren't used to a narrator who admits to knowing the whole story, I thought it might be useful to offer some examples of the involved authorial POV.

Two of them are Victorian, with all the excesses and all the vitality of the shamelessly engaged narrator. This paragraph from

*Uncle Tom's Cabin* describes the slave Eliza running away, having learned that her child is to be sold.

## *Example 11*

### Harriet Beecher Stowe: from *Uncle Tom's Cabin*

The frosty ground creaked beneath her feet, and she trembled at the sound; every quaking leaf and fluttering shadow sent the blood backward to her heart, and quickened her footsteps. She wondered within herself at the strength that seemed to be come upon her; for she felt the weight of her boy as if it had been a feather, and every flutter of fear seemed to increase the supernatural power that bore her on, while from her pale lips burst forth, in frequent ejaculations, the prayer to a Friend above — "Lord, help! Lord, save me!"

If it were *your* Harry, mother, or your Willie, that were going to be torn from you by a brutal trader, tomorrow morning, — if you had seen the man, and heard that the papers were signed and delivered, and you had only from twelve o'clock till morning to make good your escape, — how fast could *you* walk? How many miles could you make in those few brief hours, with the darling at your bosom, — the little sleepy head on your shoulder, — the small, soft arms trustingly holding on to your neck?

The power of such scenes is of course cumulative, but even in this fragment I find the author's sudden turn to the reader startling and moving — "How fast could you walk?"

Example 12 is the first pages of the first three chapters of

Dickens's *Bleak House*. The first two chapters are in the involved authorial voice, present tense; the third is in the first person, past tense, the narrator being the character Esther Summerson. The chapters alternate this way throughout the book — an unusual alternation, which I'll talk more about later.

## Example 12

### Charles Dickens: from *Bleak House*

#### CHAPTER I: IN CHANCERY

LONDON. Michaelmas Term lately over, and the Lord Chancellor sitting in Lincoln's Inn Hall. Implacable November weather. As much mud in the streets, as if the waters had but newly retired from the face of the earth, and it would not be wonderful to meet a Megalosaurus, forty feet long or so, waddling like an elephantine lizard up Holborn Hill. Smoke lowering down from chimney-pots, making a soft black drizzle, with flakes of soot in it as big as full-grown snowflakes — gone into mourning, one might imagine, for the death of the sun. Dogs, undistinguishable in mire. Horses scarcely better; splashed to their very blinkers. Foot passengers, jostling one another's umbrellas, in a general infection of ill-temper, and losing their foothold at street-corners, where tens of thousands of other foot passengers have been slipping and sliding since the day broke (if this day ever broke), adding new deposits to the crust upon crust of mud, sticking at those points tenaciously to the pavement, and accumulating at compound interest.

Fog everywhere. Fog up the river, where it flows among

green aits and meadows; fog down the river, where it rolls defiled among the tiers of shipping, and the water-side pollutions of a great (and dirty) city.

Fog on the Essex marshes; fog on the Kentish heights. Fog creeping into the cabooses of collier-brigs; fog lying out on the yards, and hovering in the rigging of great ships; fog drooping on the gunwales of barges and small boats. Fog in the eyes and throats of ancient Greenwich pensioners, wheezing by the firesides of their wards; fog in the stem and bowl of the afternoon pipe of the wrathful skipper, down in his close cabin; fog cruelly pinching the toes and fingers of his shivering little 'prentice boy on deck. Chance people on the bridges peeping over the parapets into a nether sky of fog, with fog all round them, as if they were up in a balloon, and hanging in the misty clouds.

Gas looming through the fog in divers places in the streets, much as the sun may, from the spongy fields, be seen to loom by husbandman and ploughboy. Most of the shops lighted two hours before their time — as the gas seems to know, for it has a haggard and unwilling look.

The raw afternoon is rawest, and the dense fog is densest, and the muddy streets are muddiest, near that leaden-headed old obstruction, appropriate ornament for the threshold of a leaden-headed old corporation: Temple Bar. And hard by Temple Bar, in Lincoln's Inn Hall, at the very heart of the fog, sits the Lord High Chancellor in his High Court of Chancery.

### CHAPTER II: IN FASHION

My Lady Dedlock has returned to her house in town for a few days previous to her departure for Paris, where her ladyship

intends to stay some weeks; after which her movements are uncertain. The fashionable intelligence says so, for the comfort of the Parisians, and it knows all fashionable things. To know things otherwise, were to be unfashionable. My Lady Dedlock has been down at what she calls, in familiar conversation, her "place" in Lincolnshire. The waters are out in Lincolnshire. An arch of the bridge in the park has been sapped and sopped away. The adjacent low-lying ground, for half a mile in breadth, is a stagnant river, with melancholy trees for islands in it, and a surface punctured all over, all day long, with falling rain. My Lady Dedlock's "place" has been extremely dreary. The weather, for many a day and night, has been so wet that the trees seem wet through, and the soft loppings and prunings of the woodman's axe can make no crash or crackle as they fall. The deer, looking soaked, leave quagmires, where they pass.

   The shot of a rifle loses its sharpness in the moist air, and its smoke moves in a tardy little cloud towards the green rise, coppice-topped, that makes a background for the falling rain. The view from my Lady Dedlock's own windows is alternately a lead-colored view, and a view in Indian ink. The vases on the stone terrace in the foreground catch the rain all day; and the heavy drops fall, drip, drip, drip, upon the broad flagged pavement, called, from old time, the Ghost's Walk, all night. On Sundays, the little church in the park is mouldy; the oaken pulpit breaks out into a cold sweat; and there is a general smell and taste as of the ancient Dedlocks in their graves. My Lady Dedlock (who is childless), looking out in the early twilight from her boudoir at a keeper's lodge, and seeing the light of a fire upon the latticed panes, and smoke rising from

the chimney, and a child, chased by a woman, running out into the rain to meet the shining figure of a wrapped-up man coming through the gate, has been put quite out of temper. My Lady Dedlock says she has been "bored to death."

Therefore my Lady Dedlock has come away from the place in Lincolnshire, and has left it to the rain, and the crows, and the rabbits, and the deer, and the partridges and pheasants. The pictures of the Dedlocks past and gone have seemed to vanish into the damp walls in mere lowness of spirits, as the housekeeper has passed along the old rooms, shutting up the shutters. And when they will next come forth again, the fashionable intelligence — which, like the fiend, is omniscient of the past and present, but not the future — cannot yet undertake to say.

Sir Leicester Dedlock is only a baronet, but there is no mightier baronet than he. His family is as old as the hills, and infinitely more respectable. He has a general opinion that the world might get on without hills, but would be done up without Dedlocks. He would on the whole admit Nature to be a good idea (a little low, perhaps, when not enclosed with a park-fence), but an idea dependent for its execution on your great county families. He is a gentleman of strict conscience, disdainful of all littleness and meanness, and ready, on the shortest notice, to die any death you may please to mention rather than give occasion for the least impeachment of his integrity. He is an honorable, obstinate, truthful, high-spirited, intensely prejudiced, perfectly unreasonable man.

### CHAPTER III: A PROGRESS

I have a great deal of difficulty in beginning to write my por-

tion of these pages, for I know I am not clever. I always knew that. I can remember, when I was a very little girl indeed, I used to say to my doll, when we were alone together, "Now Dolly, I am not clever, you know very well, and you must be patient with me, like a dear!" And so she used to sit propped up in a great arm-chair, with her beautiful complexion and rosy lips, staring at me — or not so much at me, I think, as at nothing — while I busily stitched away, and told her every one of my secrets.

My dear old doll! I was such a shy little thing that I seldom dared to open my lips, and never dared to open my heart, to anybody else. It almost makes me cry to think what a relief it used to be to me, when I came home from school of a day, to run up-stairs to my room, and say, "O you dear faithful Dolly, I knew you would be expecting me!" and then to sit down on the floor, leaning on the elbow of her great chair, and tell her all I had noticed since we parted. I had always rather a no-ticing way — not a quick way, O no! — a silent way of noticing what passed before me, and thinking I should like to under-stand it better. I have not by any means a quick understand-ing. When I love a person very tenderly indeed, it seems to brighten.

But even that may be my vanity.

I was brought up, from my earliest remembrance — like some of the princesses in the fairy stories, only I was not charming — by my godmother. At least I only knew her as such. She was a good, good woman! She went to church three times every Sunday, and to morning prayers on Wednesdays and Fridays, and to lectures whenever there were lectures; and never missed. She was handsome; and if she had ever

smiled, would have been (I used to think) like an angel — but she never smiled. She was always grave and strict. She was so very good herself, I thought, that the badness of other people made her frown all her life. I felt so different from her, even making every allowance for the differences between a child and a woman; I felt so poor, so trifling, and so far off; that I never could be unrestrained with her — no, could never even love her as I wished. It made me very sorry to consider how good she was, and how unworthy of her I was; and I used ardently to hope that I might have a better heart; and I talked it over very often with the dear old doll; but I never loved my godmother as I ought to have loved her, and as I felt I must have loved her if I had been a better girl.

Example 13, a bit from *The Lord of the Rings,* gives a charming glimpse of the range open to the involved author, who can drop into the POV of a passing fox. The fox "never found out any more about it," and we never find out any more about the fox; but there he is, alert and alive, all in one moment, watching for us the obscure beginning of a great adventure.

## *Example 13*

### J.R.R. Tolkien: from *The Lord of the Rings*

"I am so sleepy," he said, "that soon I shall fall down on the road. Are you going to sleep on your legs? It is nearly midnight."

"I thought you liked walking in the dark," said Frodo. "But there is no great hurry. Merry expects us some time the day

after tomorrow; but that leaves us nearly two days more. We'll halt at the first likely spot."

"The wind's in the West," said Sam. "If we get to the other side of this hill, we shall find a spot that is sheltered and snug enough, sir. There is a dry fir-wood just ahead, if I remember rightly." Sam knew the land well within twenty miles of Hobbiton, but that was the limit of his geography.

Just over the top of the hill they came on the patch of fir-wood. Leaving the road they went into the deep resin-scented darkness of the trees, and gathered dead sticks and cones to make a fire. Soon they had a merry crackle of flame at the foot of a large fir-tree and they sat round it for a while, until they began to nod. Then, each in an angle of the great tree's roots, they curled up in their cloaks and blankets, and were soon fast asleep. They set no watch; even Frodo feared no danger yet, for they were still in the heart of the Shire. A few creatures came and looked at them when the fire had died away. A fox passing through the wood on business of his own stopped several minutes and sniffed.

"Hobbits!" he thought. "Well, what next? I have heard of strange doings in this land, but I have seldom heard of a hobbit sleeping out of doors under a tree. Three of them! There's something mighty queer behind this." He was quite right, but he never found out any more about it.

If you go back to Example 8, from the "Time Passes" section of *To the Lighthouse,* you'll see the involved author moving in and out of her own perceptions and characters' points of view so swiftly and so easily that the points of view dissolve into one another and into a voice which is the "voice of the beauty of the

world," but which is also the voice of the book itself, the story telling itself. This kind of quick, unsignaled shifting, discussed further below, is rare, and takes immense certainty and skill.

## FURTHER READING

The involved author or "omniscient" author: I'm a little shy about telling anybody to go read Tolstoy's *War and Peace,* since it's quite an undertaking; but it is a wonderful book. And from the technical aspect, it's almost miraculous in the way it shifts imperceptibly from the author's voice to the point of view of a character, speaking with perfect simplicity in the inner voice of a man, a woman, even a hunting dog, and then back to the thoughts of the author . . . till by the end you feel you have lived many lives: which is perhaps the greatest gift a novel can give.

The detached narrator or "fly on the wall": Any of the writers who called themselves "minimalist," such as Raymond Carver, wrote stories that provide good examples of this technique.

The observer-narrator: Henry James and Willa Cather both used this device frequently. James used limited third person for his observer-narrators, which distances the whole story. Cather used a male witness-narrator in the first person, notably in *My Ántonia* and *A Lost Lady,* and it is interesting to speculate on why a woman writer might speak through a male mask.

The unreliable narrator: Henry James's "The Turn of the Screw" is a classic example. We'd better not believe everything the governess tells us, and we must look through what she says for what she leaves out. Is she deceiving us or herself?

Point of view in genre fiction is interesting. One might expect most science fiction to be written without getting inside

the characters, but if you read it, you'll find this is not true at all. Quite unpretentious series-novels, such as those that use the characters from *Star Trek,* may be highly sophisticated in their changes of POV.

Many mysteries are written "omnisciently," but the limitation and development of the narrator's knowledge is often the central device of a mystery, and many of the finest, like Tony Hillerman's Southwestern or Donna Leon's Venetian or Sara Paretsky's Chicago mysteries, are told from the viewpoint of the detective.

Romances are conventionally told in limited third person, through the perceptions of the heroine, but first-person, observer-narrator, and involved-author narration are equally suited to the genre.

A founding classic of the Western novel, Owen Wister's *The Virginian,* is mostly told in the first person by an Eastern greenhorn observer-narrator (and many later writers in the genre imitated this ploy). Wister switches, a little awkwardly, into authorial narration to tell us events that the observer-narrator couldn't have observed. Molly Gloss's beautiful Western novel *The Jump-Off Creek* moves back and forth between first person in diary entries and limited third person. An interesting example of personal memoir told in letters — and at one very painful point told in the third person, as if it were about someone other than the author — is Elinore Pruitt Stewart's *Letters of a Woman Homesteader.*

Changing the point of view, using various narrators, is an essential structural device of many modern stories and novels. Margaret Atwood does it wonderfully; look at The *Robber Bride,* or her short stories, or *Alias Grace* (a novel so well made and

well written that it could serve as a model for almost any topic in this book). Did you ever read or see the film of *Rashomon?* It's the classic tale of four witnesses telling four utterly different versions of the same event. *Making History,* by Carolyn See, is told in the voices of a set of narrators whose differing voices are an essential part of the book's wit and power. In my novella "Hernes" in *Searoad,* four women tell the story of a small-town family through the whole twentieth century, their voices passing back and forth among the generations. Perhaps the masterpiece of this kind of "choral" narration is *The Waves* by Virginia Woolf.

*They sailed easily from the past to the present, but now they can't get back.*

# 8. changing point of view

YOU CAN CHANGE POINT OF VIEW, OF course; it is your God-given right as an American fiction writer. All I'm saying is, you need to know that you're doing it; some American fiction writers don't. And you need to know when and how to do it, so that when you shift, you carry the reader effortlessly with you.

Shifting between first and third person is enormously difficult in a short piece. Even in a novel, like Example 12, this shift is uncommon, and may be, in the end, unwise. *Bleak House* is a powerful novel, and some of its dramatic power may come from this highly artificial alternation and contrast of voices. But the transition from Dickens to Esther is always a jolt. And the

twenty-year-old girl sometimes begins to sound awfully like the middle-aged novelist, which is implausible (though rather a relief, because Esther is given to tiresome fits of self-deprecation, and Dickens isn't). Dickens was well aware of the dangers of his narrative strategy: the narrating author never overlaps with the observer-narrator, never enters Esther's mind, never even sees her. The two narratives remain separate. The plot unites them, but they never touch. It is an odd device.

So my general feeling is, if you try the first-to-third shift, have a really good reason for doing it, and do it with great care. Don't strip your gears.

You really can't shift between detached and involved authorial voice within one piece. I don't know why you'd want to.

And once again: the involved author can move from one viewpoint character to another at will; but if it happens very often, unless the writing is superbly controlled, readers will tire of being jerked from mind to mind, or will lose track of whose mind they're supposed to be in.

Particularly disturbing is the effect of being jerked into a different viewpoint *for a moment*. With care, the involved author can do this (Tolkien does it with the fox). But it *cannot* be done in limited third person. If you're writing the story from Della's point of view, you can say, "Della looked up into Rodney's adoring face," but you can't say, "Della raised her incredibly beautiful violet eyes to Rodney's adoring face." Though Della may be well aware that her eyes are violet and beautiful, she doesn't see them when she looks up. Rodney sees them. You've shifted out of her POV into his. (If Della is in fact thinking about the effect of her eyes on Rodney, you have to say so: "She raised her eyes, knowing the effect their violet beauty would have on him.")

One-word POV shifts like that are not uncommon, but always uncomfortable.

Authorial narration and limited third person have a wide overlap, since the involved author can and usually does use third-person narration freely, and may limit perception for some while to a single person. When the authorial voice is subtle, it can be hard to say for sure which mode a piece is written in.

So: you can shift from one viewpoint character to another any time you like, if you know why and how you're doing it, if you're cautious about doing it frequently, and if you never do it for a moment only.

~~~~~~~~~~~~~~~~~~~~~~~~~~~~~~~~~

## EXERCISE EIGHT: Changing Voices

**Part One:** Quick Shifts in Limited Third: A short narrative, 300–600 words. You can use one of the sketches from Exercise 7 or make up a new scene of the same kind: several people involved in the same activity or event.

Tell the story *using several different viewpoint characters (narrators) in limited third person,* changing from one to another as the narrative proceeds.

*Mark the changes* with line breaks, with the narrator's name in parentheses at the head of that section, or with any device you like.

~~~~~~~~~~~~~~~~~~~~~~~~~~~~~~~~~

I keep saying that shifting POV frequently and without notice is risky, dangerous. So you want to do something dangerous.

~~~~~~~~~~~~~~~~~~~~

**Part Two:** Thin Ice

In 300–1000 words, tell the same story or a new story of the same kind, deliberately shifting POV from character to character several times without any obvious signal to the reader that you're doing so.

You can of course do Part Two merely by removing the "signals" from Part One, but you won't learn much by doing so. "Thin Ice" calls for a different narrative technique, and possibly a different narrative. I think it is likely to end up being written by the involved author, even though you are apparently using only limited third-person viewpoint. This ice really is thin, and the waters are deep.

~~~~~~~~~~~~~~~~~~~~

A model of this kind of POV shifting is Example 14, from *To the Lighthouse*.

## Example 14

**Virginia Woolf: from *To the Lighthouse***

What brought her to say that: "We are in the hands of the

Lord?" she wondered. The insincerity slipping in among the truths roused her, annoyed her. She returned to her knitting again. How could any Lord have made this world? she asked. With her mind she had always seized the fact that there is no reason, order, justice: but suffering, death, the poor. There was no treachery too base for the world to commit; she knew that. No happiness lasted; she knew that. She knitted with firm composure, slightly pursing her lips and, without being aware of it, so stiffened and composed the lines of her face in a habit of sternness that when her husband passed, though he was chuckling at the thought that Hume, the philosopher, grown enormously fat, had stuck in a bog, he could not help noting, as he passed, the sternness at the heart of her beauty. It saddened him, and her remoteness pained him, and he felt, as he passed, that he could not protect her, and, when he reached the hedge, he was sad. He could do nothing to help her. He must stand by and watch her. Indeed, the infernal truth was, he made things worse for her. He was irritable — he was touchy. He had lost his temper over the Lighthouse. He looked into the hedge, into its intricacy, its darkness.

Always, Mrs. Ramsay felt, one helped oneself out of solitude reluctantly by laying hold of some little odd or end, some sound, some sight. She listened, but it was all very still; cricket was over; the children were in their baths; there was only the sound of the sea. She stopped knitting; she held the long reddish-brown stocking dangling in her hands a moment. She saw the light again. With some irony in her interrogation, for when one woke at all, one's relations changed, she looked at the steady light, the pitiless, the remorseless, which was so much her, yet so little her, which had her at its beck and call

(she woke in the night and saw it bent across their bed, stroking the floor), but for all that she thought, watching it with fascination, hypnotised, as if it were stroking with its silver fingers some sealed vessel in her brain whose bursting would flood her with delight, she had known happiness, exquisite happiness, intense happiness, and it silvered the rough waves a little more brightly, as daylight faded, and the blue went out of the sea and it rolled in waves of pure lemon which curved and swelled and broke upon the beach and the ecstasy burst in her eyes and waves of pure delight raced over the floor of her mind and she felt, It is enough! It is enough!

He turned and saw her. Ah! She was lovely, lovelier now than ever he thought. But he could not speak to her. He could not interrupt her. He wanted urgently to speak to her now that James was gone and she was alone at last. But he resolved, no; he would not interrupt her. She was aloof from him now in her beauty, in her sadness. He would let her be, and he passed her without a word, though it hurt him that she should look so distant, and he could not reach her, he could do nothing to help her. And again he would have passed her without a word had she not, at that very moment, given him of her own free will what she knew he would never ask, and called to him and taken the green shawl off the picture frame, and gone to him. For he wished, she knew, to protect her.

Notice how Woolf makes the transitions effortlessly but perfectly clearly. From "What brought her to say that" to the second "she knew that," we are in Mrs. Ramsay's POV; then we slip out of it, the signal being that *we can see Mrs. Ramsay* slightly pursing her lips, composing her face "in a habit of sternness," which

Mr. Ramsay, passing, chuckling at the thought of a philosopher stuck in a bog, *sees from his POV;* and he grows sad, feeling that he cannot protect her. The paragraph indent is the signal for the switch back to Mrs. Ramsay. What are the next switches, and how are they signaled?

## A REMINDER ABOUT IMITATION

A rational fear of plagiarizing and an individualistic valuation of originality have stopped many prose writers from using deliberate imitation as a learning tool. In poetry courses, students may be asked to write "in the manner of" so-and-so, or to use a stanza or a cadence from a published poet as a model, but teachers of prose writing seem to shun the very idea of imitating. I think conscious, deliberate imitation of a piece of prose one admires can be good training, a means toward finding one's own voice as a narrative writer. If you want to imitate any of the examples in this book, or anything else, do so. What is essential is the consciousness. When imitating, it's necessary to remember that the work, however successful, is practice, not an end in itself but a means toward the end of writing with skill and freedom in one's own voice.

*In critiquing* these exercises, you might talk about how well the shifts work, what's gained (or lost?) by them, how the piece might have differed if told from one POV only.

*For a while afterward,* when reading fiction, you might take a moment to consider what POV is being used, who the viewpoint character is, when the POV shifts, and so on. It's interesting to see how different writers do it, and you can learn a great deal from watching great artists of narrative technique such as Woolf and Atwood.

*A: Lower the topgallants!*

*B: I will when I find them!*

# 9. indirect narration, or what tells

THIS CHAPTER HAS TO DO WITH VARIOUS aspects of storytelling that don't seem to be storytelling in the obvious sense of recounting events.

Some people interpret story to mean plot. Some reduce story to action. Plot is so much discussed in literature and writing courses, and action is so highly valued, that I want to put in a counterweight opinion.

A story that has nothing but action and plot is a pretty poor affair; and some great stories have neither. To my mind, plot is merely one way of telling a story, by connecting the happenings tightly, usually through causal chains. Plot is a marvelous device. But it's not superior to story, and not even necessary to it. As for

action, indeed a story must move, something must happen; but the action can be nothing more than a letter sent that doesn't arrive, a thought unspoken, the passage of a summer day. Unceasing violent action is usually a sign that in fact no story is being told.

In E. M. Forster's *Aspects of the Novel,* which I've loved and argued with for years, is a famous illustration of story: "The king died and then the queen died." And plot: "The king died and then the queen died of grief."

My opinion is that those are both rudimentary stories, the first loose, the second slightly structured. Neither one has or is a plot. "When the king's brother murdered the king and married the queen, the crown prince was upset" — now there's a plot; one you may recognize, in fact.

There are a limited number of plots (some say seven, some say twelve, some say thirty). There is no limit to the number of stories. Everybody in the world has their story; every meeting of one person with another may begin a story. Somebody asked Willie Nelson where he got his songs, and he said, "The air's full of melodies, you just reach out." The world's full of stories, you just reach out.

I say this in an attempt to unhook people from the idea that they have to make an elaborate plan of a tight plot before they're allowed to write a story. If that's the way you like to write, write that way, of course. But if it isn't, if you aren't a planner or a plotter, don't worry. The world's full of stories . . . All you need may be a character or two, or a conversation, or a situation, or a place, and you'll find the story there. You think about it, you work it out at least partly before you start writing, so that you know in a general way where you're going, but the rest works itself out in the

telling. I like my image of "steering the craft," but in fact the story boat is a magic one. It knows its course. The job of the person at the helm is to help it find its own way to wherever it's going.

In this chapter we're also dealing with how to provide information in a narrative.

This is a skill science fiction and fantasy writers are keenly aware of, because they often have a great deal of information to convey that the reader has no way of knowing unless told. If my story's set in Chicago in 2005, I can assume that my readers have some general idea of the time and place and how things were and can fill in the picture from the barest hints. But if my story's set on 4-Beta Draconis in 3205, my readers have no idea what to expect. The world of the story must be created and explained in the story. This is part of the particular interest and beauty of science fiction and fantasy: writer and reader collaborate in world-making. But it's a tricky business.

If the information is poured out as a lecture, barely concealed by some stupid device — "Oh, Captain, do tell me how the anti-matter dissimulator works!" and then he does, endlessly — we have what science fiction writers call an Expository Lump. Crafty writers (in any genre) don't allow Exposition to form Lumps. They break up the information, grind it fine, and make it into bricks to build the story with.

Almost all narrative carries some load of explaining and describing. This expository freight can be as much a problem in memoir as it is in science fiction. Making the information part of the story is a learnable skill. As always, a good part of the solution consists simply in being aware that there is a problem.

So in this chapter we're dealing with stories that tell us things

without appearing to be telling us. We're practicing invisible exposition.

The first exercise is a stark and simple one.

~~~~~~~~~~~~~~~~~~~~~~~~~

## EXERCISE NINE: Telling It Slant

**Part One:** A & B

The goal of this exercise is to tell a story and present two characters through dialogue alone.

Write a page or two — word count would be misleading, as dialogue leaves a lot of unfilled lines — a page or two of pure dialogue.

Write it like a play, with A and B as the characters' names. No stage directions. No description of the characters. *Nothing* but what A says and what B says. Everything the reader knows about who they are, where they are, and what's going on comes through what they say.

If you want a suggestion for the topic, put two people into some kind of crisis situation: the car just ran out of gas; the spaceship is about to crash; the doctor has just realized that the old man she's treating for a heart attack is her father . . .

~~~~~~~~~~~~~~~~~~~~~~~~~

*Note:* "A & B" is not an exercise in writing a short story. It's an exercise in *one of the elements* of storytelling. You may, in fact, come out with a quite satisfactory little playlet or performance piece, but the technique is not one to use much or often in narrative prose.

**Critiquing:** If you're working in a group, this is a good exercise to write in class. You'll probably find that people mutter a good deal as they write it.

If the text's clear enough for another person to read, when you come to reading it aloud, it's good fun for the author to be A and somebody else to be B (after a silent read-through). If you're very brave, give your piece to *two* other people to read aloud. If they're pretty good readers, you may learn quite a lot about how to fix it from how they read it, noticing where they stumble or mistake the emphasis and how natural or stagy it sounds.

If you're working by yourself, read it out loud. Not whispering. OUT LOUD.

In discussing or thinking about it, you may want to consider the effectiveness of the device as such (it is a tiny drama, after all). You might also think about these matters: Is the story clear? Do we learn enough about the people and the situation — do we need more information? Or less? What do we in fact know about the people (for example, do we know their gender)? What do we feel about them? Could we tell the two voices apart without the A and B signals, and if not, how might they be more differentiated? Do people actually talk this way?

**Later on:** "A & B" is a permanently useful exercise, like "Chastity." If you haven't anything better to do, you can always stick A and B in a car in the middle of Nevada, or whatever, and see what they say. Do remember, though, that unless you're a playwright,

the result isn't what you want; it's only an element of what you want. Actors embody and recreate the words of drama. In fiction, a tremendous amount of story and character may be given through the dialogue, but the story-world and its people have to be created by the storyteller. If there's nothing in it but dialogue, disembodied voices, too much is missing.

## POLYPHONY

All the same, I'm going on with voices for a while.

One of the marvelous things about that marvelous thing the novel is its many-voicedness, its polyphony. All kinds of people get to think, feel, and talk in a novel, and that great psychological variety is a part of the vitality and beauty of the form.

It might seem that the writer needs a gift of mimicry, like an impersonator, to achieve this variety of voices. But it isn't that. It's more like what a serious actor does, sinking self in character-self. It's a willingness to be the characters, letting what they think and say rise from inside them. It's a willingness to share control with one's creation.

Writers may need conscious practice in writing in voices that aren't their own; they may even resist it.

Memoirists may write only in one voice, their own. But if all the people in the memoir say only what the author wants them to say, all we hear is the author speaking — an interminable, unconvincing monologue. Some fiction writers do the same thing. They use their characters as mouthpieces for what they want to say or hear. And so you get the story where everybody talks alike and the characters are nothing but little megaphones for the author.

What's needed in this case is conscious and serious practice in hearing, and using, and being used by, other people's voices.

Instead of talking, let other people talk through you.

I can't tell a memoir writer how to do this, because I don't know how to listen for an actual voice and reproduce it truly. It's not a skill I ever practiced. I admire it in awe. Perhaps one way to begin practicing it would be to listen to people on the bus, in the supermarket, in the waiting room, and try to remember and write down their talk later, as a private exercise in fidelity to real voice.

If you're a fiction writer, though, I can tell you how to let people talk through you. Listen. Just be quiet, and listen. Let the character talk. Don't censor, don't control. Listen, and write.

Don't be afraid of doing this. After all, you *are* in control. These characters are entirely dependent on you. You made them up. Let the poor fictive creatures have their say — you can hit Delete any time you like.

~~~~~~~~~~

### EXERCISE NINE, PART 2:

## Being the Stranger

Write a narrative of 200–600 words, a scene involving at least two people and some kind of action or event.

Use a single viewpoint character, in either first person or limited third person, who is involved in the event. Give us the character's thoughts and feelings in their own words.

*The viewpoint character (real or invented) is to be somebody you dislike, or disapprove of, or hate, or feel to be extremely different from yourself.*

The situation might be a quarrel between neighbors, or a relative's visit, or somebody acting weird at the checkout counter — whatever will show the viewpoint character doing what that person does, thinking what that person thinks.

~~~~~~~~~~~~~~~~~~~~~

**To think about before writing:** When I say "the stranger," "someone extremely different from yourself," I mean it in the psychological sense: somebody you don't empathize or sympathize with easily.

A person who is profoundly different from you socially, culturally, by language, by nation, may in fact not be accessible to you as a character. You may really not know enough about their life to write about them from inside. My advice is, stick close to home. There are strangers everywhere.

For some writers who have never practiced this sort of psychological displacement, it can be hard and scary just to change gender — to write as a person of the opposite sex. If this applies to you, do it.

Many young writers have never tried to write as an old person ("old" being anything over thirty). If this applies to you, do it.

Many writers (even old ones) write of family relationships always as the child, never as a parent. If this applies to you, try writing as one of the parental, not the child, generation.

If you usually write about a certain kind of person, write about a totally different kind of person.

If you mostly write fiction, you might make this an exercise in memoir. Revive a memory of a person you have disliked, or held in contempt, or felt to be very alien to you. Take a moment you recall and tell it from that person's POV, trying to guess how they felt, what they saw, why they said what they said. How did they perceive you?

If you mostly write memoir, you might make this an exercise in fiction. Invent a person who is truly different from yourself, who's not sympathetic to you. Get inside that person's skin, think and feel as they do.

*Note:* If you're recalling actual events, don't use this exercise to rouse up sleeping demons. It's not therapy. It's just an exercise, though it's in an important aspect of writing, which does demand a certain courage of the writer.

You can use this exercise satirically, hatefully, showing us how awful the viewpoint character is by exposing what they really think and feel. That is a legitimate and canny writing tactic. But it defeats the purpose of the exercise, which is to suspend your judgment on this person. What the exercise asks of you is "to walk a mile in their moccasins," seeing the world through their eyes.

***In critiquing,*** you might use this last suggestion as a criterion. As readers, are we really inside the viewpoint character, so that we understand something about how they see the world, or did the writer stay outside, sitting in judgment, trying to force us to make the same judgment? If there's spitefulness, vindictiveness, in the piece, whose is it?

Another approach: Is the voice the piece is told in a convincing

one? Are there particular places where it rings false or rings true? Can you discuss (with others or with yourself) why this is so?

***Thinking about it afterward,*** you might consider why you chose the person you chose as the viewpoint character. And you might consider whether you found out anything about yourself as a writer, about your way of handling characters. Will you try again to write in a voice very different from your own?

Now to get away from voices entirely for a while.

Part Three of Exercise 9 is just like Part One, except it's the opposite. In "A & B" you had nothing but voices to work with, no scenery at all. In this one you have nothing to work with but the scenery. Nobody's there, and nothing — apparently — is happening.

Before doing this one, you might want to read Examples 15, 16, and 17.

The description of Jacob's room at college is light in tone, seeming not very significant. Yet the name of the book is *Jacob's Room* . . . And when we come to the end of that book, on the last page, the last two sentences of this little description are repeated word for word, with an utterly different, heartbreaking resonance. (Oh, the power of repetition!)

## Example 15

### Virginia Woolf: from *Jacob's Room*

The feathery white moon never let the sky grow dark; all night the chestnut blossoms were white in the green; dim was the cow-parsley in the meadows.

The waiters at Trinity must have been shuffling china plates like cards, from the clatter that could be heard in the Great Court. Jacob's rooms, however, were in Neville's Court; at the top; so that reaching his door one went in a little out of breath; but he wasn't there. Dining in Hall, presumably. It will be quite dark in Neville's Court long before midnight, only the pillars opposite will always be white, and the fountains. A curious effect the gate has, like lace upon pale green. Even in the window you hear the plates; a hum of talk, too, from the diners; the Hall lit up, and the swing-doors opening and shutting with a soft thud. Some are late.

Jacob's room had a round table and two low chairs.

There were yellow flags in a jar on the mantelpiece; a photograph of his mother; cards from societies with little raised crescents, coats of arms, and initials; notes and pipes; on the table lay paper ruled with a red margin — an essay, no doubt — "Does History consist of the Biographies of Great Men?" There were books enough; very few French books; but then any one who's worth anything reads just what he likes, as the mood takes him, with extravagant enthusiasm. Lives of the Duke of Wellington, for example; Spinoza; the works of Dickens; the *Faery Queen;* a Greek dictionary with the petals of poppies pressed to silk between the pages; all the Elizabethans. His slippers were incredibly shabby, like boats burnt to the water's rim. Then there were photographs from the Greeks, and a mezzotint from Sir Joshua — all very English. The works of Jane Austen, too, in deference, perhaps, to some one else's standard. Carlyle was a prize.

There were books upon the Italian painters of the Renaissance, a *Manual of the Diseases of the Horse,* and all the usual

text-books. Listless is the air in an empty room, just swelling the curtain; the flowers in the jar shift. One fibre in the wicker arm-chair creaks, though no one sits there.

The next example is the famous opening of Hardy's *The Return of the Native*. There are no characters in the first chapter at all, except Egdon Heath. Hardy's prose is circuitous and heavy-footed, and one really needs to read the whole chapter to feel how tremendously he sets the scene. If you go on and read the whole book, the character you may remember most clearly from it, years after, is still Egdon Heath.

## Example 16

### Thomas Hardy: from *The Return of the Native*

A Saturday afternoon in November was approaching the time of twilight, and the vast tract of unenclosed wild known as Egdon Heath embrowned itself moment by moment. Overhead the hollow stretch of whitish cloud shutting out the sky was as a tent which had the whole heath for its floor.

The heaven being spread with this pallid screen and the earth with the darkest vegetation, their meeting-line at the horizon was clearly marked. In such contrast the heath wore the appearance of an instalment of night which had taken up its place before its astronomical hour was come: darkness had to a great extent arrived hereon, while day stood distinct in the sky. Looking upwards, a furze-cutter would have been inclined to continue work; looking down, he would have decided to finish his faggot and go home. The distant rims of the

world and of the firmament seemed to be a division in time no less than a division in matter. The face of the heath by its mere complexion added half an hour to evening; it could in like manner retard the dawn, sadden noon, anticipate the frowning of storms scarcely generated, and intensify the opacity of a moonless midnight to a cause of shaking and dread.

In fact, precisely at this transitional point of its nightly roll into darkness the great and particular glory of the Egdon waste began, and nobody could be said to understand the heath who had not been there at such a time. It could best be felt when it could not clearly be seen, its complete effect and explanation lying in this and the succeeding hours before the next dawn: then, and only then, did it tell its true tale. The spot was, indeed, a near relation of night, and when night showed itself an apparent tendency to gravitate together could be perceived in its shades and the scene. The sombre stretch of rounds and hollows seemed to rise and meet the evening gloom in pure sympathy, the heath exhaling darkness as rapidly as the heavens precipitated it. And so the obscurity in the air and the obscurity in the land closed together in a black fraternization towards which each advanced half-way.

The place became full of a watchful intentness now; for when other things sank brooding to sleep the heath appeared slowly to awake and listen. Every night its titanic form seemed to await something; but it had waited thus, unmoved, during so many centuries, through the crises of so many things, that it could only be imagined to await one last crisis — the final overthrow.

•  •  •

We follow Jane Eyre in her first tour of Thornfield Hall. These rooms aren't empty, as Jane and the housekeeper pass through them talking; but the power of the piece is in the description of the furnishings, the rooftop and its wide bright view, the sudden return to the dim passages of the third story, and then the laugh Jane hears: "It was a curious laugh; distinct, formal, mirthless." (Oh, the power of the right adjectives!)

## Example 17

### Charlotte Brontë: from *Jane Eyre*

When we left the dining-room, she proposed to show me over the rest of the house; and I followed her upstairs and downstairs, admiring as I went; for all was well arranged and handsome. The large front chambers I thought especially grand: and some of the third-storey rooms, though dark and low, were interesting from their air of antiquity. The furniture once appropriated to the lower apartments had from time to time been removed here, as fashions changed: and the imperfect light entering by their narrow casement showed bedsteads of a hundred years old; chests in oak or walnut, looking, with their strange carvings of palm branches and cherubs' heads, like types of the Hebrew ark; rows of venerable chairs, high-backed and narrow; stools still more antiquated, on whose cushioned tops were yet apparent traces of half-effaced embroideries, wrought by fingers that for two generations had been coffin-dust. All these relics gave to the third storey of Thornfield Hall the aspect of a home of the past: a shrine of

memory. I liked the hush, the gloom, the quaintness of these retreats in the day; but I by no means coveted a night's repose on one of those wide and heavy beds: shut in, some of them, with doors of oak; shaded, others, with wrought old English hangings crusted with thick work, portraying effigies of strange flowers, and stranger birds, and strangest human beings, — all which would have looked strange, indeed, by the pallid gleam of moonlight.

"Do the servants sleep in these rooms?" I asked.

"No; they occupy a range of smaller apartments to the back; no one ever sleeps here: one would almost say that, if there were a ghost at Thornfield Hall, this would be its haunt."

"So I think: you have no ghost, then?"

"None that I ever heard of," returned Mrs. Fairfax, smiling.

"Nor any traditions of one? no legends or ghost stories?"

"I believe not. And yet it is said the Rochesters have been rather a violent than a quiet race in their time: perhaps, though, that is the reason they rest tranquilly in their graves now."

"Yes — 'after life's fitful fever they sleep well,'" I muttered. "Where are you going now, Mrs. Fairfax?" for she was moving away.

"On to the leads; will you come and see the view from thence?" I followed still, up a very narrow staircase to the attics, and thence by a ladder and through a trap-door to the roof of the hall. I was now on a level with the crow colony, and could see into their nests. Leaning over the battlements and looking far down, I surveyed the grounds laid out like a map: the bright and velvet lawn closely girdling the grey base

of the mansion; the field, wide as a park, dotted with its ancient timber; the wood, dun and sere, divided by a path visibly overgrown, greener with moss than the trees were with foliage; the church at the gates, the road, the tranquil hills, all reposing in the autumn day's sun; the horizon bounded by a propitious sky, azure, marbled with pearly white. No feature in the scene was extraordinary, but all was pleasing. When I turned from it and repassed the trap-door, I could scarcely see my way down the ladder; the attic seemed black as a vault compared with that arch of blue air to which I had been looking up, and to that sunlit scene of grove, pasture, and green hill, of which the hall was the centre, and over which I had been gazing with delight.

Mrs. Fairfax stayed behind a moment to fasten the trap-door; I, by dint of groping, found the outlet from the attic, and proceeded to descend the narrow garret staircase. I lingered in the long passage to which this led, separating the front and back rooms of the third storey: narrow, low, and dim, with only one little window at the far end, and looking, with its two rows of small black doors all shut, like a corridor in some Bluebeard's castle.

While I paced softly on, the last sound I expected to hear in so still a region, a laugh, struck my ear. It was a curious laugh; distinct, formal, mirthless. I stopped: the sound ceased, only for an instant; it began again, louder: for at first, though distinct, it was very low. It passed off in a clamorous peal that seemed to wake an echo in every lonely chamber; though it originated but in one, and I could have pointed out the door whence the accents issued.

## FURTHER READING

All the examples quoted are fairly direct in their description, yet they do not slow or stop the story. The story is in the scene, in the things described. There's a tendency to fear descriptive "passages," as if they were unnecessary ornaments that inevitably slow the "action." To see how a landscape and a great deal of information about people and a way of life can be the action, the onward movement of the story, look at Linda Hogan's *Solar Storms,* Leslie Marmon Silko's *Ceremony,* or Esmeralda Santiago's memoir, *When I Was Puerto Rican.*

In well-written, serious thrillers, such as John le Carré's *The Tailor of Panama,* information about the setting, about politics, and so on is in the same way integral to the story. Good mysteries are good at conveying information, too, from Dorothy Sayers's classic *Murder Must Advertise* and *The Nine Tailors* on. In a fantasy such as Tolkien's *The Lord of the Rings* a whole world is created and explained, effortlessly and joyously, through a wealth of vivid, concrete detail, as the story moves unceasingly forward. I believe there is no moment in that immense book in which the reader doesn't know exactly where the characters are and what the weather is doing.

Science fiction, as I said, specializes in getting a considerable amount of information to function as part of the narrative. Vonda N. McIntyre's *The Moon and the Sun* tells you more about the splendid court and eccentric courtiers of Louis XIV than many history books do, and it's all dazzling story.

Good history is all story, too — look at Hubert Herring's great *Latin America* and marvel at how he worked twenty countries

and five hundred years into a real page-turner. Stephen Jay Gould is a master at embedding complex scientific information and theory in strong narrative essays. Memoirists often seem a little old-fashioned in separating description from story; like Walter Scott back in the early nineteenth century, they show us a scene and then relate what happened there. But such deeply "placed" books as Mary Austin's *Land of Little Rain,* Isak Dinesen's *Out of Africa,* and W. H. Hudson's *The Purple Land* weave scenery, characters, and emotions into one rich and seamless fabric. In autobiographies such as those by Frederick Douglass, Sarah Winnemucca, Maxine Hong Kingston, Jill Ker Conway, and in masterful biographies such as Winifred Gerin's of the Brontës or Hermione Lee's of Virginia Woolf, the narrative carries effortlessly a wealth of information about the times, the places, the events of a life, which give the story a depth and solidity any novelist may envy. Perhaps the most masterly example I know of interweaving complex factual and technical information with a fascinating, deeply felt narrative involving many people over many years is Rebecca Skloot's *The Immortal Life of Henrietta Lacks.*

~~~~~~~~~~~~~~~~~~~~~~~~~~~~

## EXERCISE NINE, PART 3: Implication

Each part of this should involve 200–600 words of descriptive prose. In both, the voice is either involved author or detached author. No viewpoint character.

Character by indirection: Describe a *character* by describing any *place* inhabited or frequented by that

character — a room, house, garden, office, studio, bed, whatever. (The character *isn't present at the time.*)

The untold event: Give us a glimpse of the mood and nature of some event or deed by describing the *place* — room, rooftop, street, park, landscape, whatever — where it happened or is about to happen. (The event or deed *doesn't happen in your piece.*)

You aren't to say anything directly about the person or the event, which is in fact the subject of the piece. This is the stage without the actors on it; this is the camera panning before the action starts. And this kind of suggestion is something words can do better than any other medium, even film.

Use any props you like: furniture, clothes, belongings, weather, climate, a period in history, plants, rocks, smells, sounds, anything. Work the pathetic fallacy* for all it's worth. Focus on any item or detail that reveals the character or that suggests what happened or will happen.

Remember, this is a *narrative* device, part of a story. Everything you describe is there in order to further that story. Give us evidences that build up into a consistent, coherent mood or atmosphere, from which we can infer, or glimpse, or intuit, the absent person or the

untold act. A mere inventory of articles won't do it, and will bore the reader. Every detail must *tell*.

If you find "Implication" an interesting exercise, you can repeat either or both parts: this time, instead of the authorial voice, use the voice of a character in the story to describe the scene.

~~~~~~~~~~~~~~~~~~~~~~~~~~~~

*Note:* In descriptive writing, give a thought from time to time to the *senses other than sight*. Sound, above all, is evocative. We have a limited vocabulary for smell, but mention of a certain scent or stink can set a feeling-tone. Taste and touch are forbidden to the detached author. The involved author can go around telling us how things feel to the hand, though I don't think even an involved author gets to actually eat the fruit that looks so fresh and delicious, or has gotten so moldy, in the shining or the dusty wooden bowl . . . But if a character in the story is telling it, all senses can come into play.

~~~~~~~~~~~~~~~~~~~~~~~~~~~~

## *Optional Additions to EXERCISE NINE*

### The Expository Lump

My workshoppers were interested in the concept of the Expository Lump, as any writer must be, and they wanted an exercise specifically aimed at it. I said I couldn't think of one. They said, "You make up some

information that we have to work into a narrative." A delightful idea: I get to invent stuff, and you have to do all the hard work.

As my knowledge of the real world is sketchy, I provide a fantasy subject. Don't be afraid; it's just an exercise. You can return to the real world immediately after and forever.

***Option One:*** The Fantastic Lump

Study this piece of false history and invented information till you're familiar with it. Then use it as the foundation of a story or a scene. As you write the scene, compost the information: break it up, spread it out, slip it into conversation or action-narration or anywhere you can make it go so it doesn't feel Lumpy. Tell it by implication, by passing reference, by hint, by any means you like. Tell it so that readers don't realize they're learning anything. Include enough of it that readers can fully understand the situation the queen is in. This will take, I think, two or three pages, possibly more.

> The kingdom of Harath used to be ruled by queens, but for a century men have ruled and women are not permitted to. Twenty years ago, young King Pell disappeared in a battle on the border of the kingdom with the Ennedi, who are magicians. The people of Harath have never practiced magic, as their religion declares it

to be against the will of the Nine Goddesses.

What became of King Pell is not known. He left a wife but no known heir. Claimants to his throne have all been defeated by Lord Jussa, the queen's guardian, but the struggles of these factions have left the kingdom impoverished and unhappy.

At the time of our story, the Ennedi are threatening to invade on the eastern border. Lord Jussa is keeping the queen, a woman of forty, imprisoned in a remote tower under the pretext of keeping her safe. In fact he is afraid of her and alarmed by rumors of a mysterious person who managed to visit her secretly while she was in the palace. This person might be the leader of a rebel faction who is said to be the queen's illegitimate child, or it might be King Pell, or it might be an Ennedi magician, or . . .

You take it from there. You don't have to write the whole story, just a scene or two that is based on this information and includes enough of it to be understandable to a reader who has *not* read the information. The tower where the queen is being held is a good place to start. Use any viewpoint you like. You get to name the queen.

**_Option Two:_** The Real Lump

I thought this one up with memoir writers in mind. Because it deals with actual experience, I can't provide the material for you. Think of something you know how to do that involves a complex series of specific

actions: for example, making a loaf of bread, making a piece of jewelry, building a barn, designing a costume, playing a game of blackjack or a game of polo, sailing a boat, repairing an engine, setting up a conference, setting a broken wrist, setting type . . . It should be something that not everybody knows how to do, so that most readers will want some explanation of the procedures.

If nothing comes to mind, find an encyclopedia and look up a process — maybe something you always wondered about: how to make paper by hand, how to bind a book, how to shoe a horse, whatever. You'll have to use your imagination to supply the sensory details that will keep the description vivid. (Industrial processes are almost certainly too complicated to bone up on in this way, but if you already have knowledge of one, there's an excellent subject.)

Write a scene, involving at least two people, in which this process is going on, either in the background of a conversation or as the locus of the action. Keep the description specific and concrete. Avoid jargon, but if the process has a lingo of its own, use it. Whatever the process is, make the various steps clear to the reader, but don't let it appear to be what the piece is all about.

*If we dump the ballast*
*we'll be there in no time.*

# 10. crowding and leaping

TEACHING THE WORKSHOP WHERE I FIRST tried out the exercises in this book, I began to think about an aspect of narrative technique that I hadn't yet addressed. It has to do with what is included in a story and what is omitted. It has to do with details. It has to do with focus — the focus of the sentence, the paragraph, the piece as a whole. I call it Crowding and Leaping, because those words describe the process in a physical way, which I like.

Crowding is what Keats meant when he told poets to "load every rift with ore." It's what we mean when we exhort ourselves to avoid flabby language and clichés, never to use ten vague words where two exact words will do, always to seek the

vivid phrase, the exact word. By crowding I mean also keeping the story full, always full of what's happening in it; keeping it moving, not slacking and wandering into irrelevancies; keeping it interconnected with itself, rich with echoes forward and backward. Vivid, exact, concrete, accurate, dense, rich: these adjectives describe a prose that is crowded with sensations, meanings, and implications.

But leaping is just as important. What you leap over is what you leave out. And what you leave out is infinitely more than what you leave in. There's got to be white space around the word, silence around the voice. Listing is not describing. Only the relevant belongs. Some say God is in the details; some say the Devil is in the details. Both are correct.

If you try to include everything in a description, you end up like poor Funes the Memorious in Borges's story of that title, which, if you have not read it, I recommend with all my heart. Overcrowded descriptions clog the story and suffocate themselves. (For an example of a novel choked to death by words, look at *Salammbô* by Gustave Flaubert. Flaubert has been set up as such a universal model, and his *mot juste** has been made into such a shibboleth, that it's salutary to watch the poor man founder in a quicksand consisting entirely of *mots justes.*)

Tactically speaking, I'd say go ahead and crowd in the first draft—tell it all, blab, babble, put everything in. Then in revising consider what merely pads or repeats or slows or impedes your story, and cut it. Decide what counts, what tells, and cut and recombine till what's left is what counts. Leap boldly.

Action writers often crowd but fail to leap fast enough or far enough. We've all read descriptions of a fistfight, or a battle, or a sports event, which by trying to give a blow-by-blow account

merely create confusion and boredom. There's an inherent sameness to much action — the hero cuts off one knight's head, then another, then another — and mere violence doesn't make it interesting.

For a magnificent example of action writing, look at any of the sea battles in Patrick O'Brian's Aubrey-Maturin novels. Everything the reader needs to know is included, but nothing more. At each moment we know exactly where we are and what's happening. Every detail both enriches the picture and speeds the action. The language is transparent. The sensory details are intense, brief, precise. And you can't stop reading till it's over.

It's amazing how long a story a really skilled writer can tell in a few words. Consider Example 18, the life of Mr. Floyd, as told by Virginia Woolf. (Mr. Floyd, the schoolmaster, who is eight years younger than Mrs. Flanders, has proposed to her. Archer, Jacob, and John are her sons; she is a widow.)

## Example 18

### Virginia Woolf: from *Jacob's Room*

"How could I think of marriage!" she said to herself bitterly, as she fastened the gate with a piece of wire. She had always disliked red hair in men, she thought, thinking of Mr. Floyd's appearance, that night when the boys had gone to bed. And pushing her work-box away, she drew the blotting-paper towards her, and read Mr. Floyd's letter again, and her breast went up and down when she came to the word "love," but not so fast this time, for she saw Johnny chasing the geese,

and knew that it was impossible for her to marry any one — let alone Mr. Floyd, who was so much younger than she was, but what a nice man — and such a scholar too.

"Dear Mr. Floyd," she wrote. — "Did I forget about the cheese?" she wondered, laying down her pen. No, she had told Rebecca that the cheese was in the hall.

"I am much surprised . . ." she wrote.

But the letter which Mr. Floyd found on the table when he got up early next morning did not begin "I am much surprised," and it was such a motherly, respectful, inconsequent, regretful letter that he kept it for many years; long after his marriage with Miss Wimbush, of Andover; long after he had left the village. For he asked for a parish in Sheffield, which was given him; and, sending for Archer, Jacob, and John to say good-bye, he told them to choose whatever they liked in his study to remember him by.

Archer chose a paper-knife, because he did not like to choose anything too good; Jacob chose the works of Byron in one volume; John, who was still too young to make a proper choice, chose Mr. Floyd's kitten, which his brothers thought an absurd choice, but Mr. Floyd upheld him when he said: "It has fur like you." Then Mr. Floyd spoke about the King's Navy (to which Archer was going); and about Rugby (to which Jacob was going); and next day he received a silver salver and went — first to Sheffield, where he met Miss Wimbush, who was on a visit to her uncle, then to Hackney — then to Maresfield House, of which he became the principal, and finally, becoming editor of a well-known series of Ecclesiastical Biographies, he retired to Hampstead with his wife and daughter, and is often to be seen feeding the ducks on Leg of

Mutton Pond. As for Mrs. Flanders's letter — when he looked for it the other day he could not find it, and did not like to ask his wife whether she had put it away. Meeting Jacob in Piccadilly lately, he recognized him after three seconds. But Jacob had grown such a fine young man that Mr. Floyd did not like to stop him in the street.

"Dear me," said Mrs. Flanders, when she read in the *Scarborough and Harrogate Courier* that the Rev. Andrew Floyd, etc., etc., had been made Principal of Maresfield House, "that must be our Mr. Floyd."

A slight gloom fell upon the table. Jacob was helping himself to jam; the postman was talking to Rebecca in the kitchen; there was a bee humming at the yellow flower which nodded at the open window. They were all alive, that is to say, while poor Mr. Floyd was becoming Principal of Maresfield House.

Mrs. Flanders got up and went over to the fender and stroked Topaz on the neck behind the ears.

"Poor Topaz," she said (for Mr. Floyd's kitten was now a very old cat, a little mangy behind the ears, and one of these days would have to be killed).

"Poor old Topaz," said Mrs. Flanders, as he stretched himself out in the sun, and she smiled, thinking how she had had him gelded, and how she did not like red hair in men. Smiling, she went into the kitchen.

Jacob drew rather a dirty pocket-handkerchief across his face. He went upstairs to his room.

Now, the most astonishing and significant thing about this light-speed, single-paragraph biography is that it isn't really about Mr.

Floyd at all. It's only there because it casts light on Jacob, the titular subject of the novel — on Jacob's world — and on Jacob's mother, whose voice begins and ends the book. The passage seems playful, and it is. It seems a wandering-off, an irrelevance. A great deal of *Jacob's Room* does. None of it is. Woolf omits the explanations and lets the connections make themselves. She affords an extreme and admirable example of both crowding and leaping. The novel leaps over years at a time, omitting great wads of the protagonist's life. He is seldom the viewpoint character, but we get dropped into the lively minds of many people whose connection with him is left implicit. There is no plot, and the structure is a series of seemingly random glimpses and vignettes. And yet the book moves from the first word to the stunning conclusion as surely and steadily as any Greek tragedy. Whatever she's talking about, Woolf's focus is always Jacob; she never strays from the center; everything in the book contributes to the story she has to tell.

Practice in this kind of "paradoxical focus" was part of the aim of Exercise 9, Part Three, "Implication," and the two Lumps.

## A DISCUSSION OF STORY

I define story as a narrative of events (external or psychological) that moves through time or implies the passage of time and that involves change.

I define plot as a form of story that uses action as its mode, usually in the form of conflict, and that closely and intricately connects one act to another, usually through a causal chain, ending in a climax.

Climax is one kind of pleasure; plot is one kind of story. A strong, shapely plot is a pleasure in itself. It can be reused generation after generation. It provides an armature for narrative that beginning writers may find invaluable.

But most serious modern fictions can't be reduced to a plot or retold without fatal loss except in their own words. The story is not in the plot but in the telling. It is the telling that moves.

Modernist manuals of writing often conflate story with conflict. This reductionism reflects a culture that inflates aggression and competition while cultivating ignorance of other behavioral options. No narrative of any complexity can be built on or reduced to a single element. Conflict is one kind of behavior. There are others, equally important in any human life, such as relating, finding, losing, bearing, discovering, parting, changing.

Change is the universal aspect of all these sources of story. Story is something moving, something happening, something or somebody changing.

We don't have to have the rigid structure of a plot to tell a story, but we do need a *focus*. What is it about? Who is it about? This focus, explicit or implicit, is the center to which all the events, characters, sayings, doings of the story originally or finally refer. It may be or may not be a simple or a single thing or person or idea. We may not be able to define it. If it's a complex subject, it probably can't be expressed in any words at all except all the words of the story. But it is there.

And a story equally needs what Jill Paton Walsh calls *a trajectory* — not necessarily an outline or synopsis to follow, but a movement to follow: the *shape of a movement,* whether it be straight ahead or roundabout or recurrent or eccentric, a move-

ment that never ceases, from which no passage departs entirely or for long and to which all passages contribute in some way. This trajectory is the shape of the story as a whole. It moves always to its end, and its end is implied in its beginning.

Crowding and leaping have to do with the focus and the trajectory. Everything that is crowded in to enrich the story sensually, intellectually, emotionally, should be *in focus* — part of the central focus of the story. And every leap should be *along the trajectory,* following the shape and movement of the whole.

I couldn't come up with an exercise specifically aimed at such large considerations about storytelling. But there's one last exercise that's good for us all, though we may not like it much. I shall call it:

~~~~~~~~~~~~~~~~~~~~~~~

## EXERCISE TEN: A Terrible Thing to Do

Take one of the longer narrative exercises you wrote — any one that went over 400 words — and cut it by half.

If none of the exercises is suitable, take any piece of narrative prose you have ever written, 400–1000 words, and do this terrible thing to it.

This doesn't mean just cutting a bit here and there, snipping and pruning — though that's part of it. It means counting the words and reducing them to half that many while keeping the narrative clear and the sensory impact vivid, not replacing specifics by generalities, and never using the word *somehow.*

If there's dialogue in your piece, cut any long speech or long conversation in half just as implacably.

~~~~~~~~~~~~~~~~~~~~~~~~~~~

This kind of cutting is something most professional writers have to do at one time or another. Just for that reason it's good practice. But it's also a real act of self-discipline. It's enlightening. Forced to weigh your words, you find out which are the Styrofoam and which are the heavy gold. Severe cutting intensifies your style, forcing you both to crowd and to leap.

Unless you are unusually sparing with your words, or wise and experienced enough to cut as you write, revision will almost always involve some cutting of repetitions, unnecessary explanations, and so on. Consider using revision consciously as a time to consider what *could* go out if it *had* to.

This may well include some of your favorite, most beautiful and admirable sentences and passages. You are allowed to cry or moan softly while you cut them.

Anton Chekhov gave some advice about revising a story: first, he said, throw out the first three pages. As a young writer I figured that if anybody knew about short stories, it was Chekhov, so I tried taking his advice. I really hoped he was wrong, but of course he was right. It depends on the length of the story, naturally; if it's very short, you can only throw out the first three paragraphs. But there are few first drafts to which Chekhov's Razor doesn't apply. Starting a story, we all tend to circle around, explain a lot of stuff, set things up that don't need to be set up. Then we find our way and get going, and *the story begins* . . . very often just about on page 3.

In revision, as a rough rule, if the beginning can be cut, cut it. And if any passage sticks out in some way, leaves the main trajectory, could possibly come out, take it out and see what the story looks like that way. Often a cut that seemed sure to leave a terrible hole joins up without a seam. It's as if the story, the work itself, has a shape it's trying to achieve and will take that shape if you'll only clear away the verbiage.

## WAVING GOODBYE FROM THE PIER

Some people see art as a matter of control. I see it mostly as a matter of self-control. It's like this: in me there's a story that wants to be told. It is my end; I am its means. If I can keep myself, my ego, my wishes and opinions, my mental junk, out of the way and find the focus of the story, and follow the movement of the story, the story will tell itself.

Everything I've talked about in this book has to do with being ready to let a story tell itself: having the skills, knowing the craft, so that when the magic boat comes by, you can step into it and guide it where it wants to go, where it ought to go.

# *the peer group workshop*

THE WRITING WORKSHOP REPLACED THE classroom teaching of "creative writing," which all too often didn't work, with a practical technique based on the principle of mutual learning, which does work.

That is, it works if the rules are followed. Free spirits who find that the self-control required by collaborative effort sets intolerable limits on their genius won't profit from a workshop. I wonder if I myself at twenty or twenty-two would have been willing to accept the discipline of a peer group if they had existed then. They didn't. The writing workshop, guided by a leader or a peer group,* was invented long after I grew up. But that's true of a lot

of things, including texting and kale chips, in which I am less interested.

Online workshops offer an invaluable opportunity to writers who for some reason can't meet regularly, or at all, face-to-face with other writers. To form an online group or join an existing one can be a great thing for an isolated or housebound person who longs to share writing, criticism, and talk with other writers. I have experience as teacher and member only of actual workshops, but I hope my general observations and recommendations to an actual group will apply, with a bit of modification, to the procedure of a virtual group communicating online.

## THE MEMBERS

The optimum number of members for a peer group workshop is probably six or seven up to ten or eleven. A group of less than six may find itself with too few differing opinions, and meetings with only two or three attending; a group of twelve or more must be prepared for a great deal to read every month and very long work sessions. Most groups meet once a month, scheduling meetings well ahead.

A peer group works best if everybody in it is on pretty much the same level of accomplishment. A good deal of variation is tolerable and even valuable. But members working seriously at their craft will grow discouraged trying to work with people who are just playing at it with no real commitment, while the uncommitted will be bored by the serious ones. Experienced writers may feel that having to critique beginners' work is exploitation, while beginners may be daunted or oppressed by more experienced writers. Big differences in basic familiarity with written

style, including punctuation, sentence structure, even spelling, can make such disparities awfully uncomfortable. Yet there are groups that contain wide disparities with no discomfort at all. The great thing is to find the right bunch of people, the people you can trust.

## MANUSCRIPTS

Sending manuscripts out to the group, once a process involving paper, stamps, time, and so on, is now a matter of clicking the Send button. In the actual group, manuscripts (mss.) should go out to everybody *at least a week before* the meeting or the agreed session date, so that they can be read and thought over and annotated. Mss. that arrive late will not receive critique till next time. The virtual group must decide whether to let critiquing begin whenever a ms. is sent out and be carried on in a continuous intercorrespondence or to limit discussion to a definite period, in consideration for members who have only limited time for reading and critiquing and their own writing.

I recommend that you agree on a limit to the length of any one ms. submitted to one session. Once you've found the right length, stick to it firmly. I suggest that it be a word limit, not a page limit, because wordy writers, deviously using small fonts and narrow margins, can cram 500 words on a page.

If you meet in person, and if everybody in your group wants to hear a few pages of each ms. read aloud before critique, by all means do so; it's often enjoyable to hear how the author's voice "explains" the piece. In a poetry workshop, reading aloud is SOP. For a prose narrative group, however, it may take too much time. Reading aloud is a performance, which may conceal flaws and

unclarities. It goes by too fast for most hearers to make useful notes for critiquing. And after all, the destiny of most prose narrative is to be read in silence. The piece has to explain itself on the page, speak for itself, make itself "heard" by the editor who decides to publish or not publish it and by all its readers once it's published. (Then, if it's a success, it might get an audio edition.) If it was written seriously, it deserves to be read and considered seriously, in solitude, in silence. I consider that kind of slow, silent, thoughtful reading the greatest honor the group can do the piece.

## READING THE MANUSCRIPTS

Everyone writes, everyone reads. That's the basic agreement on which the group stands or falls. Reading the other workshoppers' work is as important to your membership in the group as writing and submitting your own work. Careless reading, delay in reading, and failure to read are forgivable only as occasional exceptions.

Nitpicks, spelling and grammar corrections, and small queries are best written directly on the ms., which is given back to the author to study at leisure. The online group must work out how to do this; one solution is for everybody to have the same editing software on their computer.

## CRITIQUING

It's an ugly, technical, useful word . . . But critiquing is the essential function of the writing group — along with the requirement of producing the manuscripts.

Online, at present, unless people can Skype as a group, critiques must be written. In an actual group, notes and comments can be written on the manuscript or given to the author, but they should not replace spoken commentary and discussion. The critiquing session, the interchanges and interactions of the whole group in discussions, are very often the most valuable to the author.

### Rotation

Every person critiques every piece.

Online, critiques may be read as they come in; order isn't important. In an actual meeting, it is. Each ms. submitted is critiqued in turn. Everyone in the group (except the author) speaks in turn.

Ideally, free critique is possible — only those who want to speak do, with no time limit on the critique and no order of rotation. But don't try it until you all know that nobody in the group is habitually silent or eternally blabby and that nobody is allowed to dominate. Mutual respect and trust are absolutely essential to a workshop, and free critique does permit expansive egos to silence shyer ones. Many, perhaps most, peer groups do regular mutual critiquing for years using the right-round-the-circle mode as the fairest and least stressful.

### Protocol

Each critique should be:

Brief.

Without interruption from anyone else.

Concerning important aspects of the piece. (Trivial quibbles should be written on the ms.)

Impersonal. (Your knowledge of the author's character or intentions is absolutely irrelevant. It's the writing that's under discussion, not the writer. Even if the piece is autobiographical, say "the narrator," not "you.")

As you take your turn voicing or e-mailing your critique, avoid challenging the other critiquers. No sneers; no put-downs; no flame-throwing.

Enlarge the group discussion without repeating. If you agree with Jane's comment, say so. If you disagree with what Bill said, say so without animosity, and explain how and why you disagree.

Remember that first impressions, reactions from a first reading, even misunderstandings, can be extremely useful. After all, when the author submits the piece to an editor, everything may depend on that editor's first impressions. Don't feel stupid about saying or sending naive reactions or questions, but take care that they're spoken or written without animosity and with the sole purpose of trying to improve the ms.

Criticism tends to focus on what's wrong. To be useful, negative criticism should indicate the possibility of revision. Tell the writer where you were confused or surprised or annoyed or delighted, which parts you like best. It's at least as useful to the author to hear what works, what's right.

Savage negative judgments on the whole quality of the piece may arouse the author's anger and refusal to listen, or may do real and lasting harm. The sadistic practice of the critic who assumes the privilege of dismissing work as utterly worthless,

the idea that critical judgment can be absolute, the notion that abuse makes people artists — all that still exists but has no place whatever in a workshop. The peer group, founded on mutual trust and respect, rejects both the domineering ego and the self-abasing sycophant.

Address the author, not the others.

You may ask the author only a direct, factual, yes-or-no question, and you may ask it only if you tell the group your question first and get their consent to ask it. The reason for this is that others in the group may not want the question answered. Let's say you want to ask, "Did you mean for us not to know who Della's mother is?" Others may prefer to read the text as if they didn't know the author and couldn't ask questions — as we read most narratives — and judge it from that basis. Never ask the author a question that requires a long explanation or defense. If the text itself doesn't answer the question, the most useful thing you can do may be to make a note calling attention to the problem, which the author can then fix when revising.

Suggestions for how to fix something may be valuable but should be offered respectfully. Even if you're sure you see just how it ought to be changed, this story belongs to its author, not to you.

Don't say what the story reminds you of in literature or the movies. Respect the text as itself.

Consider what this story is about; what it tries to do; how it fulfills itself; how it might achieve its ends better.

If you have some members whose critiques are habitually long-winded, the actual group may have to get a kitchen timer and limit each critique to a few minutes, and the virtual group

may have to set a word limit. A group that tolerates egocentric, tiresome, blabby critiquing probably won't stay together long. Intensity is essential; interplay is essential.

In the actual group, when people keep their critiques short, the session may end with a general, free discussion, often the best part of it all. I imagine something similar happens with online interactions. In such free discussion the group may arrive at a "sense of the meeting." But it may end in a dozen different opinions and be just as useful and exciting.

## BEING CRITIQUED

The Rule of Silence: Before and during the entire session, the author of the story under discussion is *silent*.

As author, offer *no* preliminary explanations or excuses.

If asked to answer a question, be sure the whole group is willing for you to do so, and be as brief as is humanly possible.

While being critiqued, *make notes* of what people say about your story, even if the comments seem stupid. They may make sense later. Note any comment that keeps coming up from different people. Do the same with online critique.

When all the discussion of your piece is over, you may speak if you want to. Keep it brief. Don't go into defense mode. If you have a question about your story that wasn't addressed, ask it now. By far the best response to your hardworking critics is "Thank you."

The Rule of Silence seems arbitrary. It isn't. It is an essential, sometimes I think *the* essential, element of the process.

It's almost impossible for an author whose work is being criticized not to be on the defensive, eager to explain, answer, point

out — "Oh, but see, what I meant was . . ."; "Oh, I was going to do that in the next draft." If you aren't allowed to do this, you won't waste time (yours and theirs) trying to do it. Instead, you will listen. Because you can't answer, you won't be busy mentally preparing what you're going to say in answer. All you can do is hear. You can hear what people got from your piece, what they think needs some work, what they misunderstood and understood, disliked and liked about it. And that's what you're there for.

Working online, if you keep the Rule of Silence and do not reply to critique, the critiquers will reply to one another. Their criticisms are likely to change, develop, deepen during this interchange. Your job is to read them, and think, and make notes. And at the end, say thanks.

If you truly can't endure the Rule of Silence, probably you don't really want to know how other people respond to your work. You choose to be the first and last judge of it. In this case, you won't fit happily in a group. This is absolutely OK. It's a matter of temperament. Some artists can work only in solitude. There may be periods in an artist's life when they need the stimulus and feedback of a group, and periods when they do better working alone.

Always, in the last analysis, on your own or in a group, you are your own judge, and you make your own decisions. The discipline of art is freedom.

# *glossary*

**Affect**  A noun, with the accent on the first syllable; it means feeling, emotion. It doesn't mean effect.

**Alliteration**  "Peter Piper picked a peck of pickled peppers" is an alliterative sentence. So is "Great big gobs of greasy grimy gopher guts."

**Armature**  A frame, like the steel frame of a skyscraper.

**Articulated**  Connected, joined together, as in "an articulated skeleton" and "an articulated bus."

**Clause**  A clause is a group of words that has a subject and a predicate.

The first part of that sentence — "A clause is a group of words" — can stand alone and so is called the main clause. Its subject is the noun *clause.* Its predicate is the verb *is* plus the direct object "a group of words." Because it's the main clause, those are also considered to be the subject and predicate of the sentence as a whole.

A subordinate clause can't stand alone but relates to the main clause. In the sentence above, the subordinate clause is "that has a subject and a predicate." Its subject is "that" and its predicate is "has a subject and a predicate."

Clauses can relate to one another in complicated ways when expressing complicated thoughts or situations, and those that turn up inside one another, like Chinese boxes, which you open only to find yet another box inside, are said to be "embedded."

(The embedded clause in that sentence is "which you open only to find yet another box inside.")

**Colloquial**  Spoken language as contrasted to written language; or, in writing, an easygoing, informal tone that imitates speech. The two Mark Twain pieces in our examples are beautiful pieces of colloquial writing. Most narrative, even if not highly formal, is not fully colloquial.

**Critiquing**  The process of discussing a piece of writing in a workshop or peer group. This peculiar word replaced *criticizing,* maybe because *criticize* and *criticism* have gathered a negative charge, while *critique* and *critiquing* still sound neutral.

**Dingbat**  We all know some dingbats. A dingbat is also a little figure or device used to decorate or emphasize a break in the text, like this:

**Embedded clause**  *See* Clause.

**Grammar**  The fundamental system of a language; the rules for using words so they make sense. People can have good grammatical sense without knowing the rules, but to break the rules wisely, you have to know the rules well. Knowledge is freedom.

**Metaphor**  An implied comparison or description. Instead of saying A is like B, you say A is B, or you use B to refer to A. So instead of "She's as mild and docile and lovable as a lamb," you say, "She's a lamb." Instead of "I'm reading bits here and there like a cow eating bits of grass here and there," you say, "I'm browsing through the book."

A great deal of language usage is metaphorical. Most insults are metaphors: "You dingbat!" "That old fart." One thing writers have to watch for is the common, dead metaphors, which when mixed come dreadfully alive: "Everybody in this department is going to have to put on his thinking cap, get down to brass tacks, and kick ass."

**Meter**  A regular rhythm or beat. Lub-dub-lub-dub … ta DUM ta DUM ta DUM … tiddy-dum, tiddy-dum, tiddy DUM DUM DUM … If prose develops meter for more than a few words in a row, it stops being prose and turns into poetry, whether you want it to or not.

**Mot juste**  French for the "right word."

**Onomatopoeia**  A word that sounds like what it means, like *sizzle* or *hiss* or *slurp,* is onomatopoeic. As for the word *onomatopoeia,* it sounds like onna-matta-peeya.

**Parts of speech**  Classes of words, determined by their use in the sentence, such as noun, pronoun, verb, adverb, adjective, preposition. Such words may bring back horrid memories of school, but it's

impossible to criticize grammar or understand criticism of grammar without this vocabulary.

**Pathetic fallacy** A phrase, too often used condescendingly, to describe a passage of writing in which the landscape, weather, and other things mirror or embody human emotions.

**Peer group** A group of writers who meet regularly to read and discuss one another's writing, forming a leaderless workshop.

**Person (of the verb)** The English verb has six persons, three in the singular number and three in the plural. Here are examples of a regular verb (***work***) and an irregular verb (***be***) in the present and past tenses.

*first singular:* I work; I am / I worked; I was
*second singular:* you work; you are / you worked; you were
*third singular:* he, she, it works; he, she, it is / he, she, it
   worked; he, she, it was
*first plural:* we work; we are / we worked; we were
*second plural:* you work; you are / you worked; you were
*third plural:* they work; they are / they worked; they were

Person and number affect the verb forms only in the third-person singular of the present tense and in all persons of the singular present tense of the irregular verb ***to be.***

**Sentence fragment** A piece of sentence used in place of a whole sentence.

A sentence has a subject (a noun or name or pronoun) and a predicate (a verb and its objects). (The subject of that sentence is ***sentence*** and the predicate is "has a subject and a predicate.") A fragment lacks either the subject or the predicate or both:

No sentence fragments!
Going where?
Too late, too late.

We use them all the time in talking, and in writing, too; but in writing, what's left out must be clearly implied by the context around the fragment. Repeated use of fragments in narrative tends to sound either awkward or affected.

**Simile** A comparison using *like* or *as:* "She turned as red as a turkey." "My love is like a red, red rose." The difference between simile and metaphor is that the comparison or description is made openly in simile — "I watch like a hawk" — while in metaphor the *like* or *as* disappears: "I am a camera."

**Stream of consciousness** A name for a fictional mode or voice developed by the novelists Dorothy Richardson and James Joyce, in which the reader participates in the moment-to-moment experience, reactions, and thoughts of the viewpoint character. Though very constrictive when used throughout a whole novel, passages of stream of consciousness are common and effective in long works, and the mode is well suited to short pieces and present-tense narration.

**Syntax** "(2.) The arrangement of words (in their appropriate forms) by which their connexion and relation in a sentence are shown." — *The Shorter Oxford English Dictionary*

Recognition of syntactical constructions used to be taught by the method of diagramming, a useful skill for any writer. If you can find an old grammar book that shows you how to diagram a sentence, have a look; it's enlightening. It may make you realize that a sentence has a skeleton, just as a horse does, and the sentence, or the

horse, moves the way it does because of the way its bones are put together.

A keen feeling for that arrangement and connection and relation of words is essential equipment for a writer of narrative prose. You don't need to know all the rules of syntax, but you have to train yourself to hear it or feel it, so that you'll know when a sentence is so tangled up it's about to fall onto its nose and when it's running clear and free.

**Tenses** The forms of a verb that indicate the times at which the action is supposed to be happening.